IMAGES
of America

WHEN BOSTON
RODE THE EL

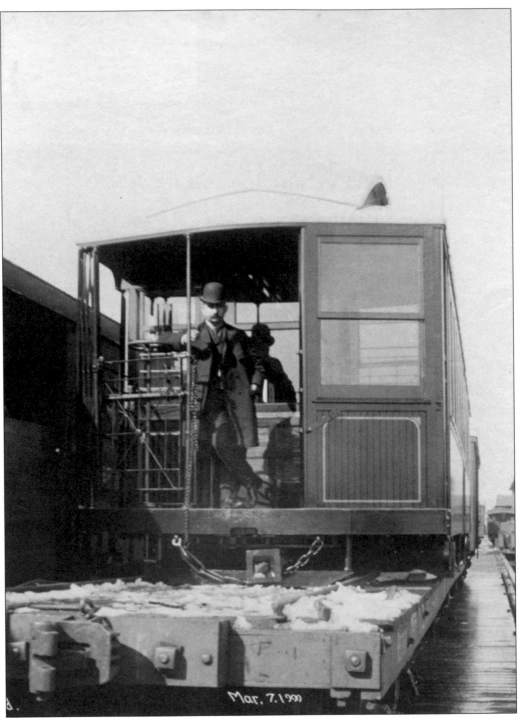

Mar. 7. 1900

Boston's first elevated car arrived from the Wason Car Works in Springfield, Massachusetts, on March 7, 1900. Shown at Boston's old North Station is Car 03, one of the three cars ordered for use in demonstrating electrical and air brake equipment from several manufacturers that wished to supply the equipment for Boston's new elevated system.

IMAGES
of America

WHEN BOSTON RODE THE EL

Frank Cheney and
Anthony Mitchell Sammarco

ARCADIA

First published in 2000.

Published by Arcadia Publishing,
an imprint of Tempus Publishing, Inc.
2 Cumberland Street
Charleston, SC 29401

Printed in Great Britain.

Library of Congress Catalog Card Number: 00-104042

For all general information contact Arcadia Publishing at:
Telephone 843-853-2070
Fax 843-853-0044
E-Mail sales@arcadiapublishing.com

For customer service and orders:
Toll-Free 1-888-313-2665

Visit us on the internet at http://www.arcadiapublishing.com

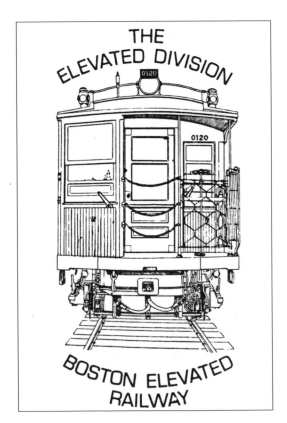

This drawing of Car 0120 of the Boston Elevated Railway is from the title page of the 1901 *Rule Book for Employees of the Elevated Lines.*

CONTENTS

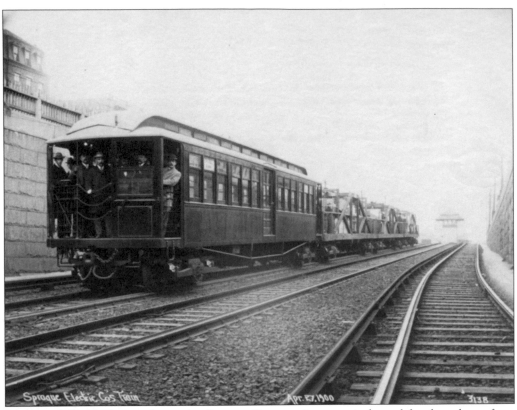

This April 27, 1900 view shows the Sprague Company's test train bound for the subway from North Station. The trials lasted from April 1 to May 2, 1900, and attracted railway officials from across the United States. On the front platform of this train are Stuart S. Neff of the Chicago Elevated Railway; William A. Bancroft, president of the Boston Elevated Railway; Frank J. Sprague at the controls; and George Cornell, chief engineer of the Brooklyn Elevated Railway, leaning out of the door.

ACKNOWLEDGMENTS

When Boston Rode the El is the third transportation book by the authors that outlines the 86-year history of the Boston Elevated Railway, which connected Forest Hills Station in Jamaica Plain to Sullivan Square Station in Charlestown, Massachusetts. These fascinating photographs offer poignant and often rare images of this once vital transportation link in Boston, which meandered through the city both above and below ground.

We would like to offer our thanks to Anthony Bognanno, Cleo and Sam, Dexter, Joseph LoPiccolo, the late Stanley R. Perry, David Rooney, Anthony and Mary Mitchell Sammarco, Rosemary Sammarco, the late William Werner, and all the present and past employees of the Massachusetts Bay Transit Authority, the successor to the Boston Elevated Railway.

INTRODUCTION

June 10, 1901, was a day that gave Boston's renowned civic pride a major boost; for on that bright summer day, the Boston Elevated Railway Company presented the most modern elevated rapid transit system in the nation to the city's transit riders. On that day, Boston joined with New York and Chicago in possessing a true rapid transit system free from the congestion of crowded city streets. Boston had already opened America's first subway back on September 1, 1897, the beginning of the present Green Line system. New York did not open its first subway until October 24, 1904, and Philadelphia's elevated and subway system opened on March 4, 1907. It was therefore with justifiable pride that crowds of Bostonians gathered at 5:00 on that June morning outside the big new elevated terminals at Dudley Street in Roxbury and Sullivan Square in Charlestown, hoping to be aboard the first trains to roll over the new elevated system.

As the station attendants swung open the big entrance gates at both the Sullivan Square and Dudley Street Terminals, the crowds surged up the stairs and rushed onto the platforms, after dropping their nickels into the coin boxes. On the platforms, they were met by throngs of people who had just arrived on the first trolley cars that had rolled up the ramps to the elevated level only moments before. At exactly 5:30 a.m., the departure gongs sounded in the terminals, and the jam-packed trains moved out, starting 86 years of elevated service in Boston. The Boston El cars that went into service that morning were painted a handsome aurora red with silver gilt striping and slate gray roofs. The interiors of the cars featured varnished African mahogany woodwork with sky-blue ceilings and bronze hardware features. The seats were upholstered in attractive red-and-black mottled plush. Many early risers in houses along the elevated routes were surprised on that first morning of operation to have scores of passing strangers observing their morning routines! Henceforth, most window shades were pulled down along the elevated routes. The aurora red trains rolled over elevated structures painted a deep olive green and stopped at handsome stations sheathed in burnished copper—a pity that color photography was decades away.

The highly successful opening day of Boston's elevated system was the culmination of decades of debates, heated disputes, and attempts to build an elevated railway system in the city that began shortly after Charles Harvey opened New York City's first elevated line running above Ninth Avenue in December 1867. After inspecting the new Ninth Avenue El Line, the Boston Common (City) Council decided that such a system was not needed in Boston. However, a wide variety of proposals for elevated systems kept popping up like mushrooms on a lawn after a warm summer rain. These proposals encompassed various types of unproved

technology, including the use of compressed-air or battery-powered locomotives, narrow gauge, and three rail and monorail systems. One of these, the Meigs Monorail system, received serious consideration from the state authorities in the 1884–1887 period, and a full size demonstration line was built near Lechmere Square in East Cambridge by the inventor, Joe V. Meigs. Meigs, however, failed to acquire sufficient financial backing for his system, and the demonstration line was dismantled in 1894. In July 1890, the West End Street Railway Company, the operator of Boston's extensive surface streetcar system, was granted authority to build an elevated system to be operated with conventional electric trolley cars, but the company took no action to do so. Finally, in June 1891, the state legislature appointed a rapid transit commission to study Boston's transit problems and come up with a solution. After considerable debate, legislation based on the Rapid Transit Commission's recommendations was enacted in July 1894. The legislation created the Boston Transit Commission to build the Tremont Street Subway, which was to be leased to and operated by the West End Street Railway. The legislation also created a franchise for the Boston Elevated Railway Company to be awarded to private interests to build an elevated railway system to serve the Boston area.

The Boston Elevated franchise was quickly acquired by a group that included Joe V. Meigs, who had failed in his earlier attempt to build a monorail system. Meigs and his group again failed to raise sufficient funding to build their steam-powered, standard two-rail elevated system and offered to sell their valuable elevated franchise to the West End Street Railway for $150,000. The conservative West End management declined the offer, which infuriated several leading West End stockholders, including Eben M. Jordan, Boston's department store magnate, and Gen. William A. Bancroft, an influential lawyer and businessman. Obtaining backing from J.P. Morgan & Company, the Jordan-Bancroft Group purchased the elevated franchise from the Meigs group, after which they started a proxy battle that allowed them to gain control of the West End Street Railway Company. They then arranged the lease of the entire West End Surface Car System to the new Boston Elevated Company in December 1897, thus guaranteeing Boston an unified transit system, free from the damaging competition that prevailed between the elevated and surface systems in New York and Chicago.

On January 20, 1899, the official groundbreaking ceremony for Boston's new elevated system finally took place on Washington Street in the South End when the two-year-old son of company president William A. Gaston turned the first spade of earth—albeit with a bit of assistance. In only two years and five months, the company completed the largest construction project in the city's history. Under the able direction of chief engineer George A. Kimball, the company built seven miles of elevated structure with ten stations above the busy streets of Boston, constructed two large multilevel terminals, built a huge generating station, set up two car repair shops, altered six subway stations for use by the elevated trains, and designed and acquired 150 elevated cars of the most advanced type—all within budget. This was a remarkable accomplishment when compared with present-day transit projects with their endless delays and huge cost overruns.

Upon completion of the Roxbury, Charlestown, and Atlantic Avenue El Lines, the company focused on completing the design work on the Cambridge El Line, to connect Harvard Square with downtown Boston. However, Cambridge officials decided that they wanted a subway rather than an elevated line, and after a heated political battle, the company consented to build a subway from Harvard Square to Park Street, which is today part of the Red Line system. Construction of the planned elevated to South Boston was quietly dropped as being an uneconomical proposition. In 1904, as ridership continued to climb at a rapid rate on the elevated lines, two projects were undertaken to handle the increasing business: the construction of a new tunnel under Washington Street for the elevated trains, enabling the removal of the trains from the Tremont Street Subway, in November 1908; and the extension of the Washington Street Elevated southward from Dudley Street to Forest Hills Square, which began operation on November 1, 1909. Plans for another elevated extension, from Sullivan Square to Malden Square, were dropped when the city of Malden insisted on a subway after construction

had been started on the new line. The line was quickly terminated at a temporary station on Broadway in Everett just across the Mystic River from Sullivan Square Terminal. The elevated line from North Station to Lechmere Square in East Cambridge was designed to be part of the Main Line Elevated System, but today it is part of the Green Line and is Boston's last elevated line.

As originally operated, the three elevated lines—Roxbury, Charlestown, and Atlantic Avenue—were run as six routes, enabling a passenger to board a train at any station and ride to any other station without changing trains. With the opening of the Washington Street Tunnel in 1908, the Atlantic Avenue Line was reduced to a North Station–South Station shuttle line, except for limited rush-hour periods, which led to a big drop in patronage. However, ridership on the Main Line from Forest Hills to Everett Station reached 288,000 passengers per day in 1929, and the Boston newspapers ran numerous stories alleging severe overcrowding on the trains and "cattle pen" conditions at the busy Dudley Street and Sullivan Square Terminals. During the Depression, ridership dropped considerably—especially on the Atlantic Avenue Line, where commercial and maritime activity also declined. Although the line was colorful in many ways—with its excellent views of Boston's waterfront and its transport of the U.S. mail on nine trips per day, with pickup at South Station, State Street, and North Station—economics caused it to close on September 30, 1938.

As the Depression ended and World War II (with its gas and tire rationing) approached, transit ridership increased greatly. By 1943, the Boston transit system as a whole carried 1,475,000 riders on an average day, with 325,000 of those riders squeezed aboard the Main Line El trains. In September 1947, the Metropolitan Transit Authority (MTA) took over the Boston Elevated System, and plans were made to replace both the Washington Street and Charlestown Els with subways. However, the state did not authorize the funding. Seventeen years later, in 1964, the Massachusetts Bay Transit Authority (MBTA), or the T, as it became known, replaced the MTA. That year, the MBTA announced a master plan that included the construction of 56 miles of new rapid transit lines to cost $300,000,000 with a completion date in mid-1970, at which time the elevated lines would be removed. However, this long-awaited program was never completed, collapsing amidst financial, political, and construction problems after only 23 miles of new routes were built at the astounding cost of $1,642,498,000. This sad situation greatly prolonged the life of the elevated lines beyond their planned 1970 demise. The Charlestown El finally closed amidst a nasty spring snow and sleet storm, ignored by hundreds of last-trip riders, who jammed aboard the final train, which left Everett Station at 7:24 p.m. on April 4, 1975.

The Washington Street Elevated survived for better than another decade. In 1975, it was rehabilitated and repainted in an attractive blue-and-orange color scheme at a cost of over $3,000,000. As the new Southwest Corridor Rapid Transit Commuter Rail (built to replace the Washington Street El) neared completion in the fall of 1986, residents along the Dudley Street–Washington Street section of the elevated requested that the T retain the elevated from downtown as far south as Dudley Station—a plan discussed with local residents in 1971 and 1972—at least until the new light-rail line, promised as a permanent replacement, could be completed. Claiming that there were not enough cars on hand to operate both the new Southwest Corridor and a shortened elevated line to Dudley Street, the T quickly had 70 spare cars stored at the Wellington Shops scrapped by a local salvage firm before the South End civic groups became aware of their existence, making retention of the Boston El a moot point. Early on the morning of Friday, May 1, 1987, the 86 years of elevated train operation in Boston ended when the last train rolled over the Washington Street El from Forest Hills into Boston. Accompanied by his wife for the historic occasion, motorman Edward O'Connell had the distinction of operating Boston's last elevated train.

Just as Boston's elevated system was born amidst heated dispute, so too it ended in a sea of heated controversy. After the removal of the El was completed, the long-promised light-rail line for Washington Street was canceled, resulting in a decade-long battle between the

residents of Boston's South End and the T. As Boston was making a great effort to get rid of its elevated lines, the attitude in other cities was slowly changing. New York, Philadelphia, and Chicago—after careful consideration—decided on the basis of economic and transportation considerations to retain their remaining elevated lines and subsequently have spent many millions of dollars rehabilitating and modernizing them to serve another generation of riders into the next century.

Alexander Wadsworth Longfellow was commissioned by the Boston Elevated Railway Company to design the stations along the El Line. A noted architect, he was a relative of the great poet and author, Henry Wadsworth Longfellow. (Sammarco collection.)

This stock certificate of the Boston Elevated Railway Company had four shares owned by Howard M. Phinney on July 6, 1925. Note the image of an El train passing over the Charlestown High Bridge as streetcars and other traffic pass under the El, with Boston's skyline in the distance. (Courtesy of Joseph LoPiccolo.)

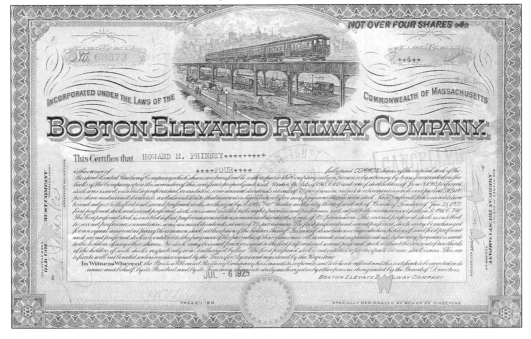

One

BUILDING THE EL

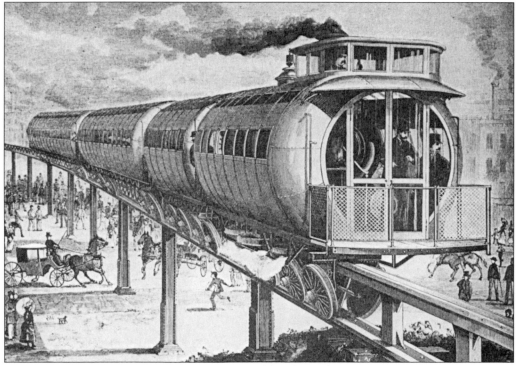

This rather accurate drawing from a promotional brochure shows a train of the Meigs Monorail Elevated System, which relied on both vertical and horizontal wheels gripping a center beam to provide total safety.

Of the many elevated railway systems proposed for Boston in the 1888–1891 period, two rather unconventional systems were reviewed at length by the state legislature, including the Macke Three-Rail System shown in this drawing. The large center wheel with double flanges was guaranteed to prevent derailments under any conditions.

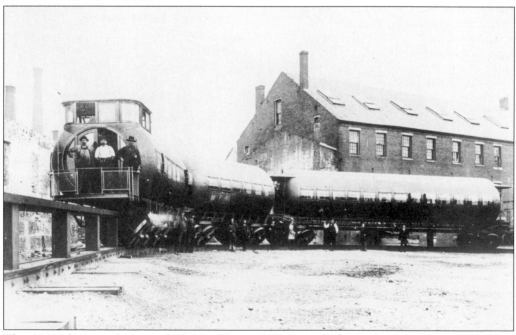

This 1888 photograph shows the Meigs Elevated Train on the grounds of the J.P. Squires Meat Packing Plant in East Cambridge, Massachusetts. This demonstration line was just over one-quarter of a mile in length and was dismantled in 1894.

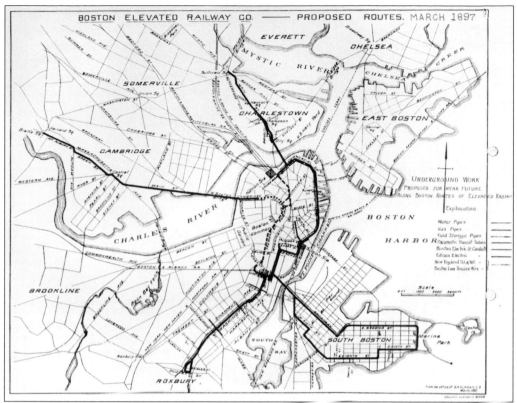

On this 1897 map is the Boston Elevated System, as approved by the state legislature, including the Roxbury to Charlestown, Cambridge, South Boston, and Atlantic Avenue Lines. The Cambridge Line was built as a subway, and the South Boston Line was dropped from the plans.

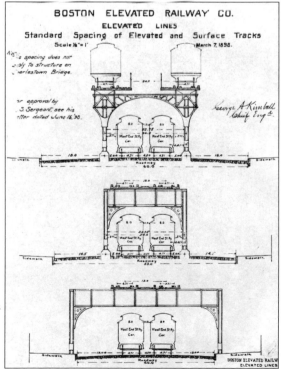

The Boston Elevated Company wisely chose to use only proven technology for its structures and equipment. This drawing shows the three basic types of elevated structures that were used, depending on the street width and conditions.

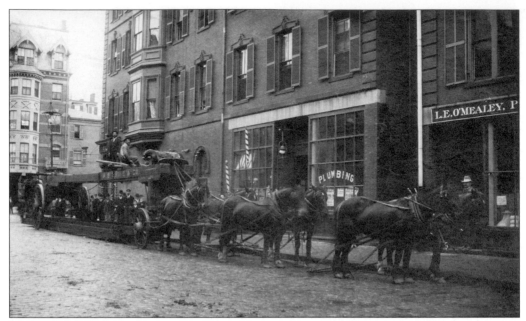

In the days before heavy motortrucks, real horsepower was employed to haul heavy cargo, as exemplified by this six-horse hitch of the R.S. Brine Company of Boston, shown delivering steel girders for the Washington Street Elevated on November 1, 1899. The R.S. Brine Company later converted to motortrucks and became a leading rigging firm in the Boston area.

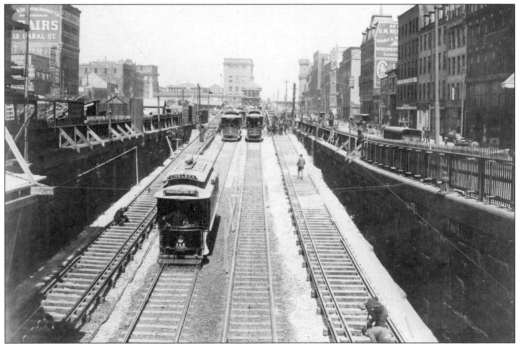

In this view looking from Haymarket Square toward North Station on April 29, 1900, workmen connect track from the Tremont Street Subway to the Charlestown Elevated Line while trolley cars of the Boston Elevated Company and the Lynn & Boston Railroad Company enter and leave the subway on the center tracks.

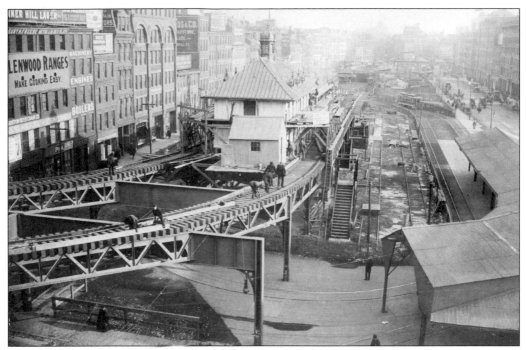

This busy scene on February 20, 1901, shows the workers of the E.B. Badger Coppersmith Company applying the burnished copper covering to the El station at North Station. The view looks toward Haymarket Square, with Haverhill Street on the left and Canal Street on the right.

Construction of the Charlestown High Bridge is well under way by the Boston Transit Commission in this March 27, 1899 view, looking from Keany Square toward City Square in Charlestown. When completed, the bridge carried trolley cars and general traffic, as well as the trains on the Charlestown El. This bridge is still in use for motor vehicle and pedestrian traffic.

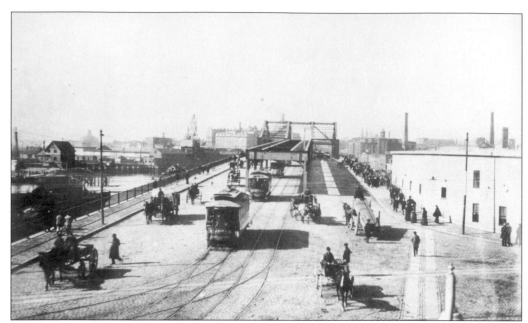

This view shows the new Charlestown High Bridge in November 1900, complete and open to traffic, with a section of the elevated structure in place. Note the crowds promenading over the bridge to admire Boston's latest major civic improvement.

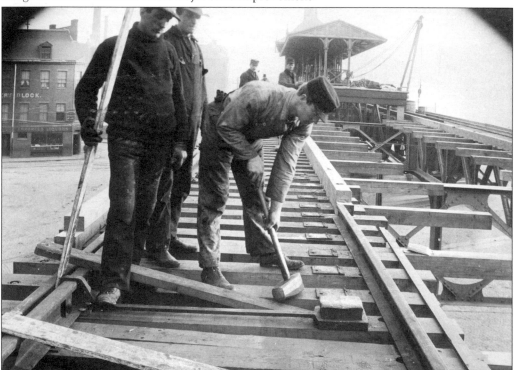

Before the advent of pneumatic and electric power tools, most construction work required hard physical labor, as demonstrated by these workers using lining bars, sledgehammers, and muscle to install track on the Charlestown El at City Square Station on January 8, 1901.

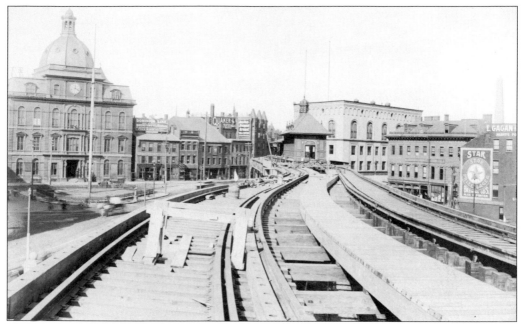

Looking north toward City Square on February 18, 1901, there is scarcely a living soul to be seen in this usually busy area. The elevated structure and the station are nearly complete. The old Charlestown City Hall is on the left, and the Bunker Hill Monument is visible above the buildings on the right.

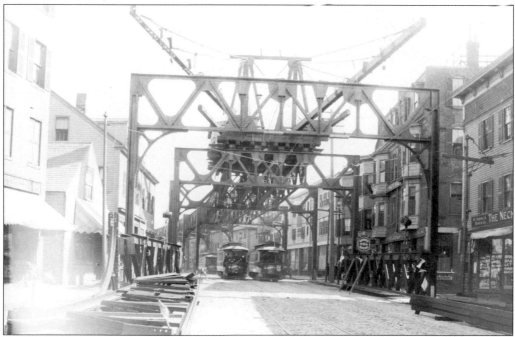

This view looking along Main Street at Bunker Hill Street on May 11, 1900, shows trolley cars from Roxbury and Medford passing under the partially completed elevated structure. Ready to be added to the structure are several heavy cross girders, stacked on the pavement. The Neck Market on the right features a variety of vegetables, including dandelion greens.

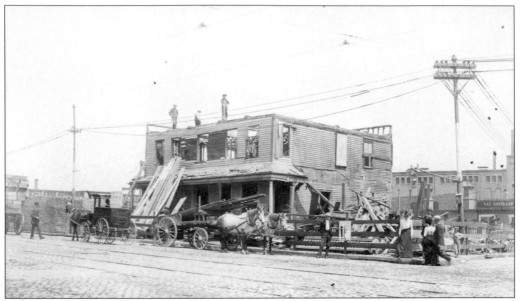

Among the many properties removed in 1900 to make way for the big Sullivan Square Terminal was this former inn at Main and Alford Streets, which once served the users of the Boston to Portsmouth mail stages and the Middlesex Canal boats. In later years, the inn became a tavern and gained a rather unsavory reputation.

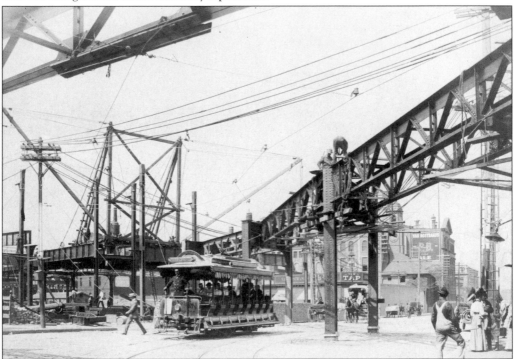

By August 16, 1900, the old inn has vanished from the corner of Main and Alford Streets, and work on the El structure and terminal building moves rapidly along. The big Van Nostrand Brewery with its historic bell tower rises in the background. The open trolley is en route from Woodlawn in Everett to Scollay Square in Boston.

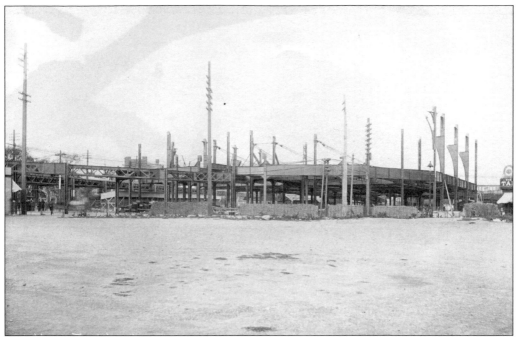

In this October 2, 1900 view looking from Alford Street, the steel framing of the Sullivan Square Terminal building takes shape. Built to last, the substantial steel frame was covered with a skin of brick and stone.

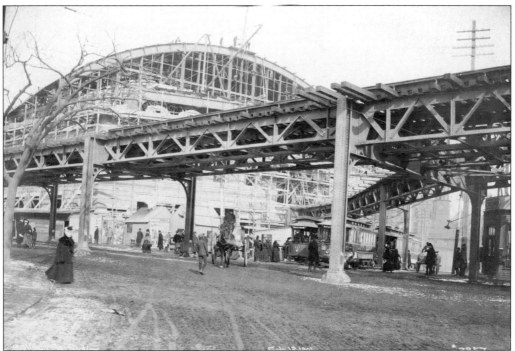

Once again at Main and Alford Streets, this time on February 12, 1901, the big Sullivan Square Terminal is well on the way to completion, unhampered by modern-day construction delays. The trolleys are ready to depart for Roxbury Crossing, Maplewood, and Ferry Street in Everett.

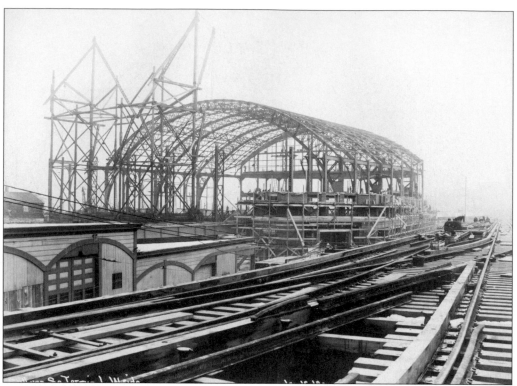

Despite the frigid winter weather, the steel framing of the terminal building was nearly complete. This photograph was taken on January 16, 1901, from the southbound elevated tracks above Main Street in Charlestown.

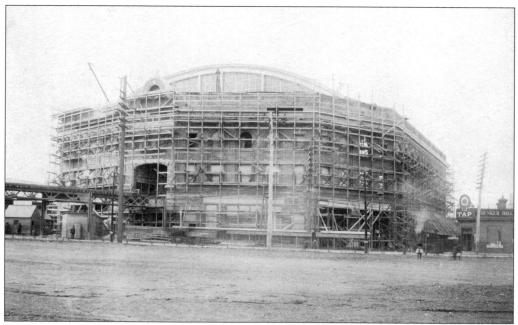

Here is the same scene on March 13, 1901. The Sullivan Square Terminal is nearly complete in preparation for opening day, which was June 10, 1901.

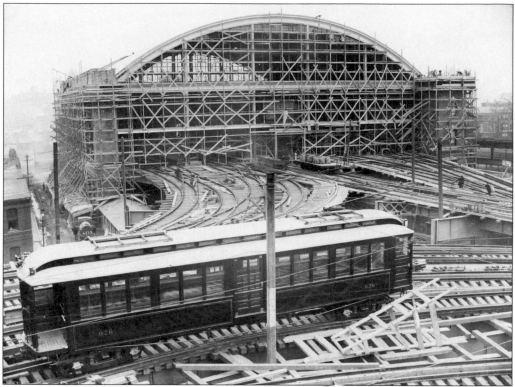

This March 8, 1901 view of the north end of the terminal shows 11 tracks entering the upper level of the building used by the elevated trains and trolley cars. The lower level contained a double-loop track for trolley cars. Also shown is one of the brand-new elevated cars.

It is obviously frigid and windy as these workmen apply the roof covering to the big arched train shed at Sullivan Square on February 12, 1901. This northward view shows Broadway in Somerville over the shoulder of the gentleman on the left wearing the derby.

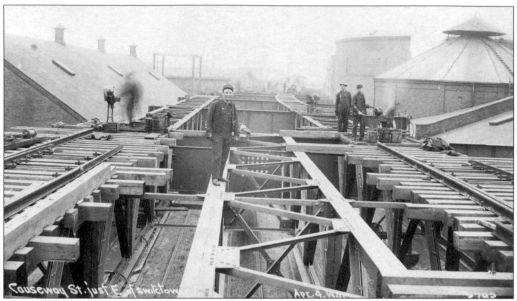

These hardworking riveters pause to smile for the company photographer on April 4, 1901, while working on the Atlantic Avenue elevated structure above Commercial Street near Keany Square. The round brick structures on the right were part of the old North End Gas Works.

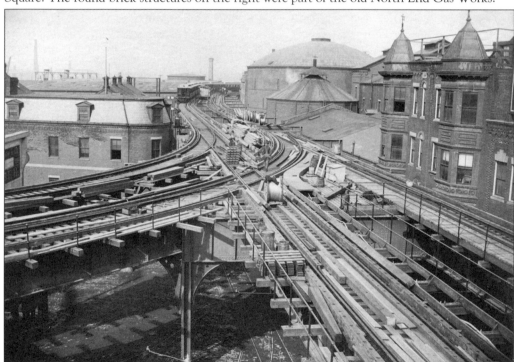

Shown is the junction of the Charlestown and Atlantic Avenue elevated lines as seen from Signal Tower C above Keany Square in the North End on May 14, 1901. A line of new elevated cars is stored on the nearly completed Atlantic Avenue Line. The North End Gas Works is visible on the right of the El. The famous Great Molasses Flood of 1919 took place just beyond the standing El cars.

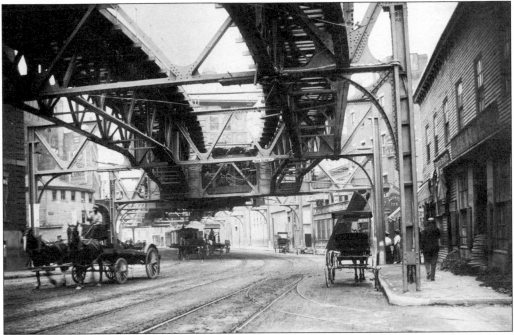

This view, looking northward on Commercial Street in June 1901, shows the nearly completed Battery Street El Station built to serve the North Ferry Dock. Although the state legislature authorized the elevated company to operate steam railroad passenger and freight trains over the Atlantic Avenue El (linking the North and South Stations), the elevated company never exercised the right.

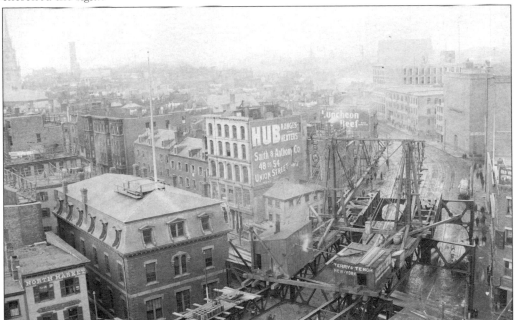

This March 4, 1901 view of Commercial Street and the North End was taken from the roof of the Boston Elevated Company's new Lincoln Wharf Power Station. The famous steeple of the Old North Church is on the left, and Constitution Wharf is on the right.

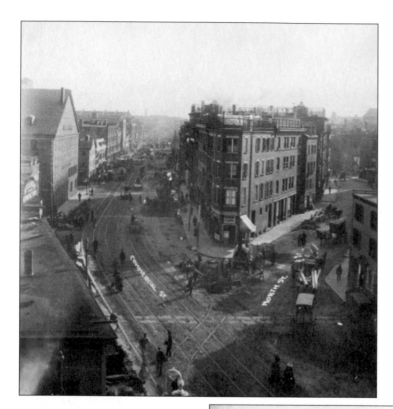

This view looks southward along Commercial Street at North Street on November 3, 1899, just before the Atlantic Avenue Elevated was erected. The granite bulk of Union Wharf is on the left.

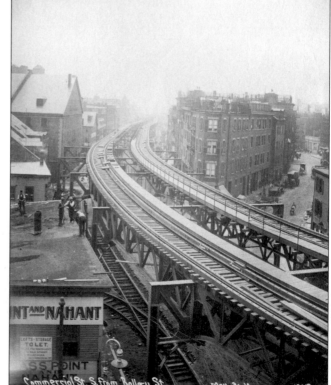

Shown is the same scene on May 21, 1901, with the elevated nearly complete and ready for operation, which commenced some three months later. On the left, workmen apply another layer of tar to the roof of the Bass Point and Nahant Steamship Line offices.

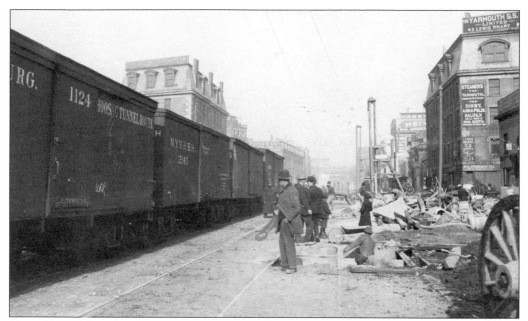

Some idea of the vibrant commercial activity of Boston's waterfront a century ago is offered in this view of Atlantic Avenue, looking northward on November 9, 1899. The foundations for the Atlantic Avenue El are being dug on the right in front of Lewis Wharf as a freight train passes on the left.

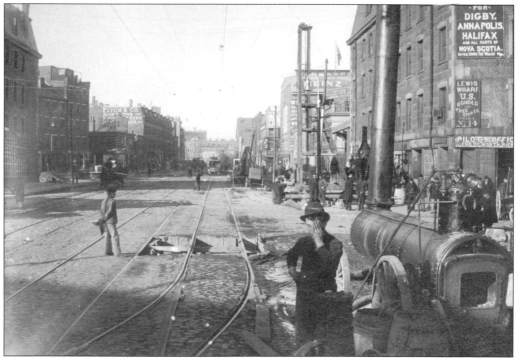

Again looking northward on Atlantic Avenue, the view shows a steam-powered pile driver on the right preparing the footings for the new Atlantic Avenue Elevated. Lewis Wharf on the right was typical of the large granite commercial buildings that once lined Atlantic Avenue.

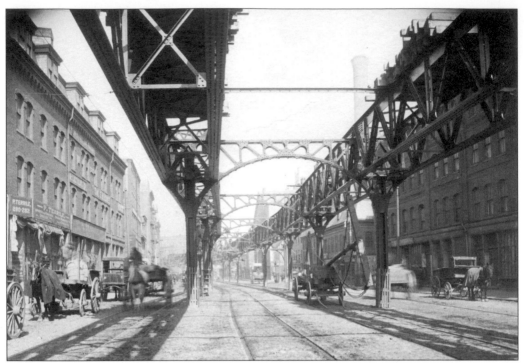

Shown is Commercial Street, looking north near Lincoln Wharf, with the steelwork of the Atlantic Avenue El completed and awaiting installation of the cross ties and rails. It must have been cold in this March 7, 1901 view, as most of the horses are wearing heavy blankets.

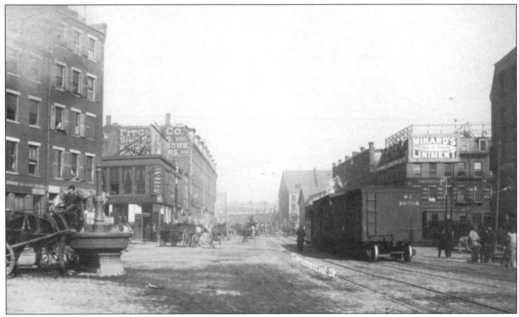

It is November 13, 1899, in this view looking northward at the junction of Atlantic Avenue and Commercial Street just before the construction of the El. One of the dummy steam locomotives of the Union Freight Railroad hauls two boxcars along the avenue, while two horses enjoy a drink from the public horse fountain on the left.

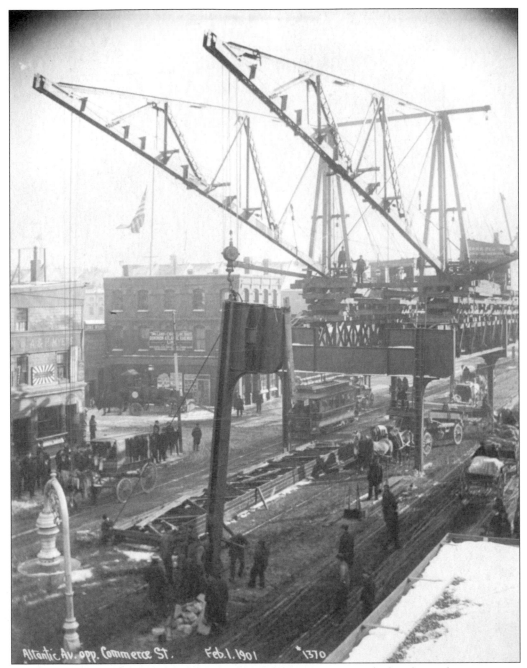

Shown is Atlantic Avenue at Long Wharf on February 1, 1901, with the elevated construction crew hoisting another girder into place, while an interested crew of sidewalk construction experts watches on the left. Late deliveries of steel delayed completion of the Atlantic Avenue line until August 1901.

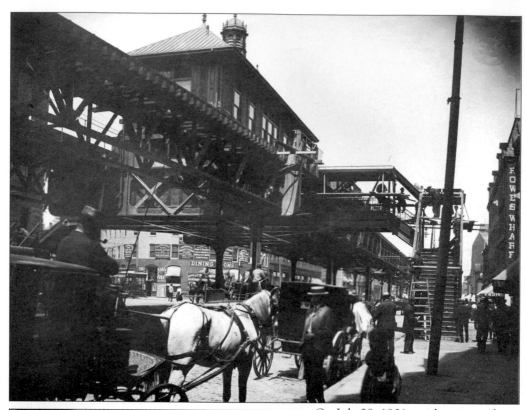

On July 29, 1901, workmen put the finishing touches on the Rowe's Wharf Elevated Station. Rowe's Wharf, seen on the right, served local steamers to Nantasket, Plymouth, and Provincetown, as well as a line of ferries to East Boston. All of this maritime activity was a big source of traffic for the Atlantic Avenue El.

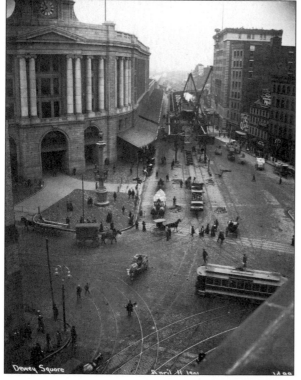

This view from the roof of the Wentworth Building on April 11, 1901, shows Dewey Square with Atlantic Avenue, looking southward. The massive, recently opened South Station is on the left, with the new Hotel Essex on the right. Construction of the Atlantic Avenue El is under way in the center.

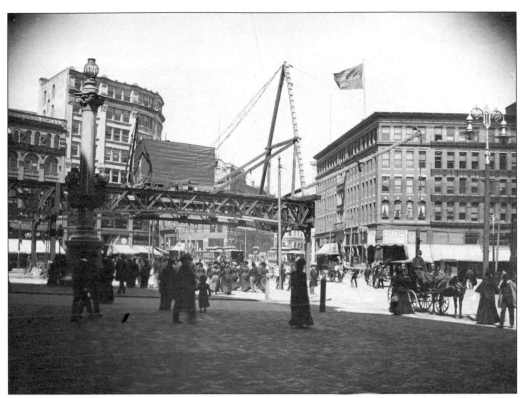

In this photograph taken from in front of South Station only a day later, the El structure is already halfway across Dewey Square. Note the monument to Admiral Dewey on the left and the Wentworth Building on the right, a longtime landmark that fell victim to highway construction in 1955.

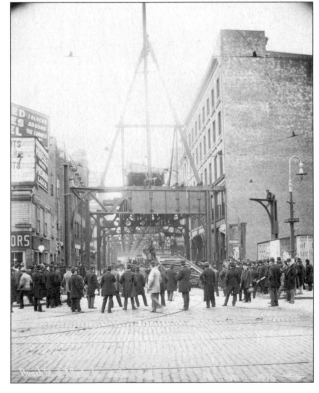

Here, the new El structure has advanced down Beach Street to the corner of Atlantic Avenue on the morning of April 1, 1901. A crowd of sidewalk superintendents is watching with great interest as workmen prepare to hoist a large cross girder into place.

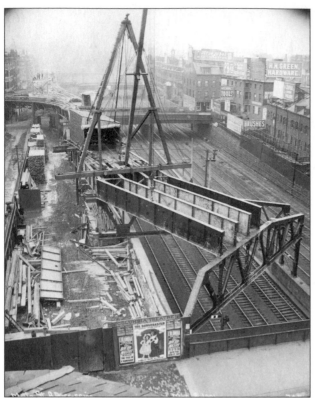

The Atlantic Avenue Elevated Line branched from the Washington Street Elevated at the corner of Washington and Motte Streets, known as Castle Square, seen in the upper left of this March 8, 1901 view. The railroad tracks in the center are the main lines of the New Haven and Boston & Albany Railroads, which now handle MBTA commuter and Amtrak intercity trains. Harrison Avenue is in the foreground.

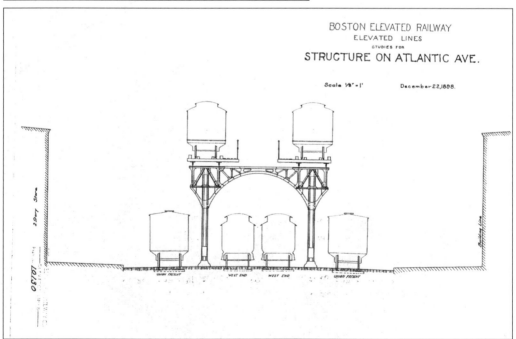

The El structure along Atlantic Avenue had to be located above four lines of surface tracks for most of the distance. This engineering drawing shows the location of the trolley car tracks and Union Freight Railroad tracks in relation to the El structure.

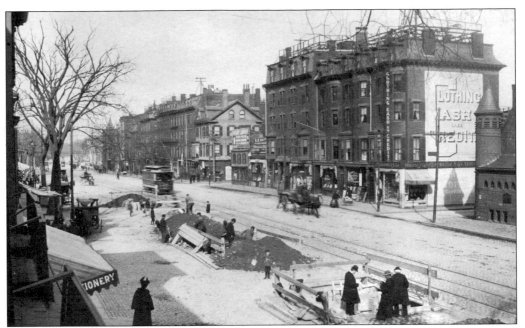

Unlimited sunlight still bathes Washington Street at Arnold Street before the erection of the El structure, which cast its shadow for 86 years. In this April 3, 1899 view, workmen prepare the foundations to support the vertical girders of the El.

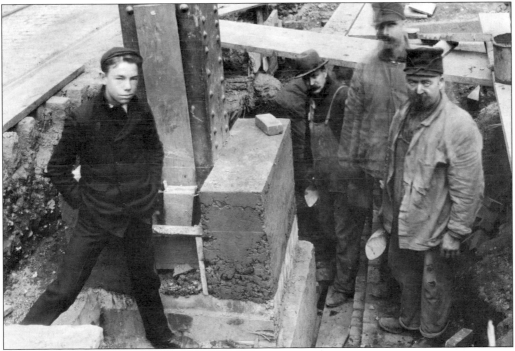

The foundations of the El structure were quite substantial and in most areas extended at least 12 to 15 feet below the surface of the street. On November 27, 1899, these workmen were applying concrete around a support girder at Washington and Waltham Streets. The youth on the left appears in a number of company photographs and must have been related to an El official.

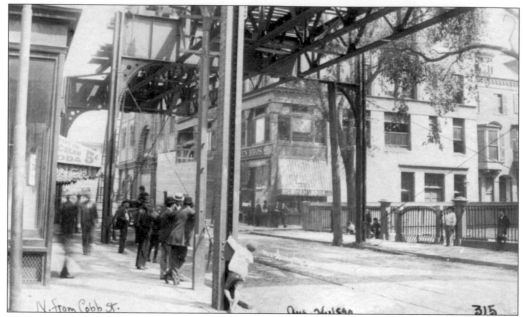

Shown is the first section of the El structure to be erected on Washington Street at Cobb Street. Among the onlookers in this August 26, 1899 view is a typical barefoot boy, so common in long ago summers.

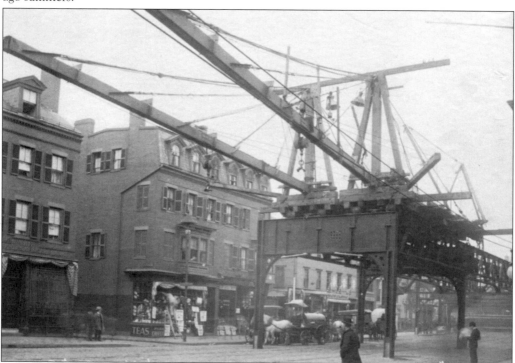

The large cranelike device sitting atop the El structure in this view at Washington and Groton Streets was known as a traveler. After lifting the girders and setting them in place, the traveler, which was sitting on rollers, moved forward on the newly completed section of El and repeated the procedure.

32

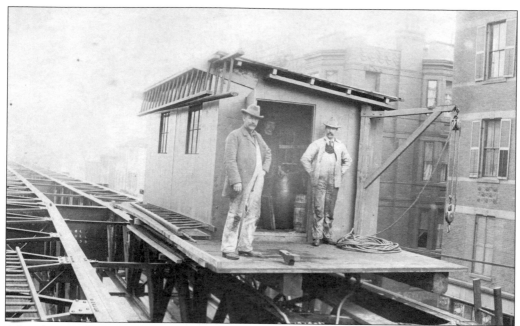

After the installation and riveting of the steelwork was completed, the painters moved along the structure with their paint shop—a shed mounted on rollers, as seen here on December 18, 1899. The painters would apply a base coat of lead primer and a finish coat of glossy olive green.

This view taken on April 20, 1899, from a rooftop on Corning Street looks toward Castle Square, with the Shawmut Avenue and Washington Street Bridges crossing the New Haven and Boston & Albany Railroad tracks, on the left. The byzantine structure at Castle Square is the Columbia Theater, a longtime South End landmark.

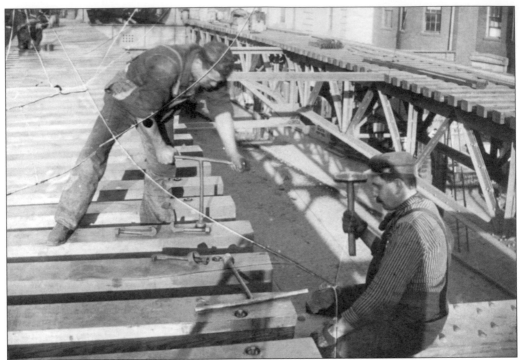

In this photograph made from a cracked glass plate negative, workmen fasten the wooden cross ties to the steel El structure at Washington and Dover Streets on November 12, 1900. Needless to say, these men really earned their pay.

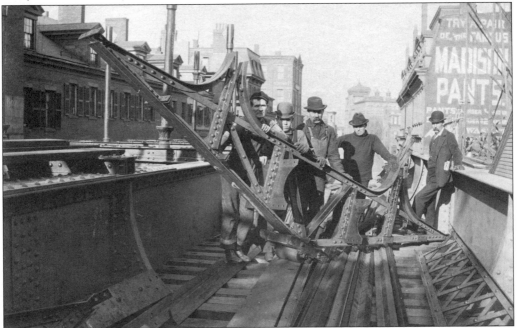

Thankful for a moment's pause to pose for the company photographer on November 12, 1900, this serious-looking crew was about to manhandle one of the roof trusses for the Dover Street Station into place.

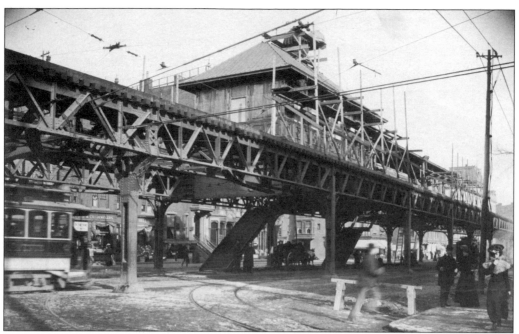

Looking northward on Washington Street at Northampton Street on January 21, 1901, this view shows the Northampton Street Station nearing completion. All of the way stations along the El system were of a standard design and, along with the two major terminals, all were designed by Alexander Wadsworth Longfellow, a member of the famous Longfellow family.

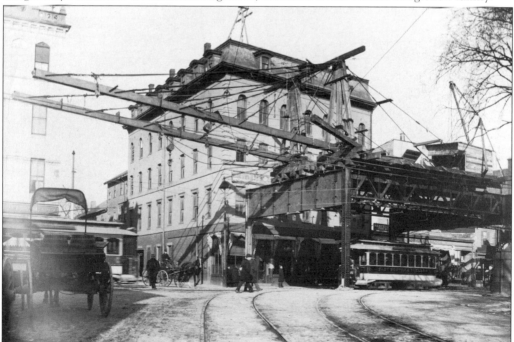

By January 11, 1900, when this photograph was taken, the El structure had advanced as far as Eustis Street in its march southward along Washington Street. The trolley car beneath the El was en route from the East Boston Ferry Dock on Atlantic Avenue to Dudley Street in Roxbury.

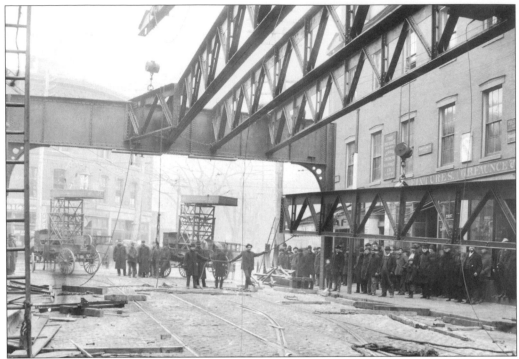

An interested crowd of onlookers gathers at the corner of Washington and Dudley Streets on January 25, 1900, to watch as another large girder is hoisted into place on the El structure. Note the two trolley wire repair wagons waiting to reinstall the trolley car wires as soon as the girder is fastened into place.

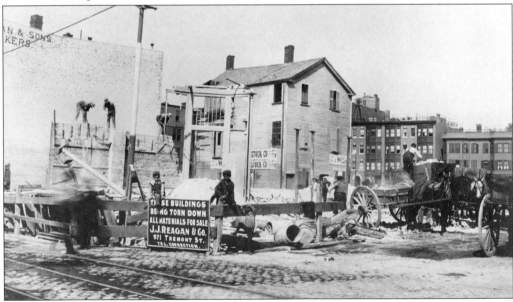

In order to avoid needless delays in the construction of its elevated system, the Boston Elevated Company was granted the right of eminent domain to acquire the 83 businesses and residential properties required for transit purposes. In this May 10, 1899 photograph, the building demolition is under way on the site of the future Dudley Street Terminal.

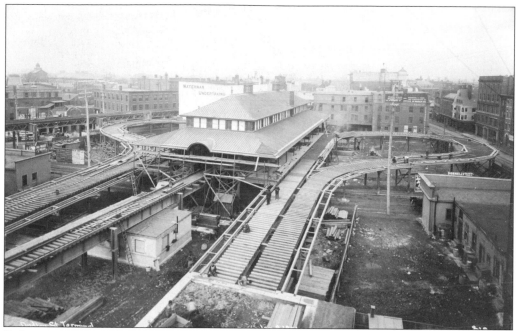

By January 9, 1901, the Dudley Street Terminal is well on its way to completion. This terminal became one of the busiest stations on the El system; by July 1929, more than 73,000 passengers per day entered the station to transfer between surface cars or to board the El trains.

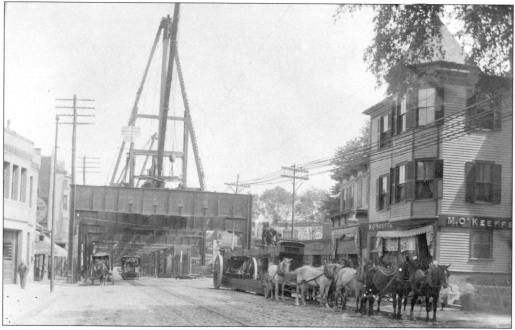

On the warm afternoon of August 30, 1906, an eight-horse hitch of the R.S. Brine Rigging Company has just delivered two heavy grinders for the Forest Hills Elevated extension at Washington and Atherton Streets. The M. O'Keefe Grocery Store on the right was one of many stores in Boston owned by the O'Keefe chain, which was later absorbed by the First National Stores.

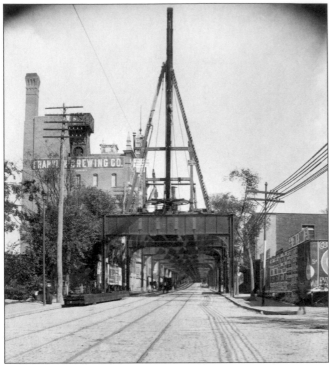

This view looking north on Washington Street on September 25, 1906, shows that the Forest Hills Elevated extension has reached the plant of the Franklin Brewing Company. In use for many years as a storage warehouse, the handsome building still stands today.

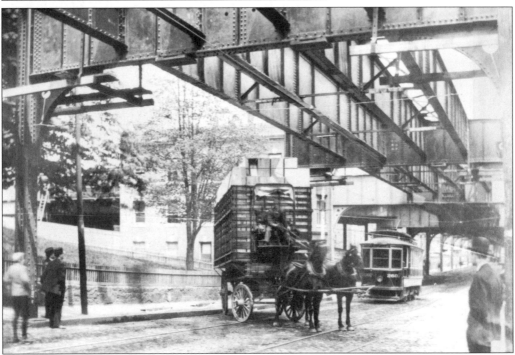

On the afternoon of May 12, 1906, this wagon with a rather high load of crates became ensnarled in the trolley car wires under the new El structure on Washington Street, just south of Guild Street. The incident delayed the Old Colony Street Railway Company trolley bound for West Roxbury and Dedham. An interested group of onlookers is already gathering.

In order to blend with the parklike setting of the Arborway at Forest Hills Square, a special design of El structure was chosen for that area. It was to be covered with concrete and built to resemble a viaduct. Shown in this August 11, 1908 photograph is the first portion of that section, with additional steel being delivered.

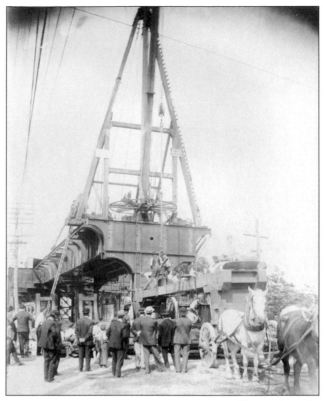

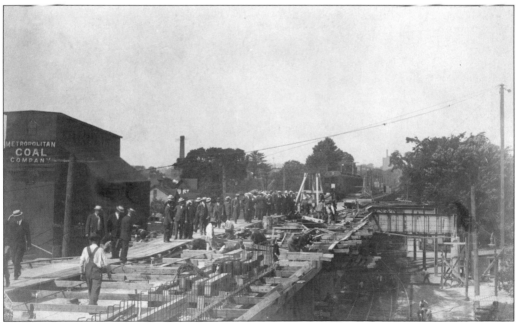

The specially designed section of El structure at Forest Hills aroused great interest among designers and engineers, since it was to be covered with concrete. In this July 1909 scene, a group of civil engineers from Boston has arrived by special train to inspect the structure before the application of the concrete.

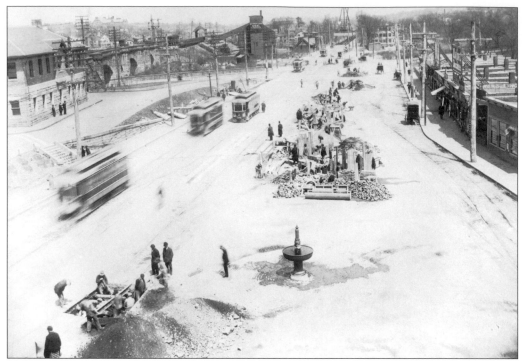

The spacious and bucolic atmosphere of Forest Hills Square in this April 22, 1908 view looking northward is about to change, as work is soon to begin on the foundations for the new El terminal, which will occupy a large part of the square. The Forest Hills Railroad Station is on the left where the new Forest Hills Station of the MBTA now stands.

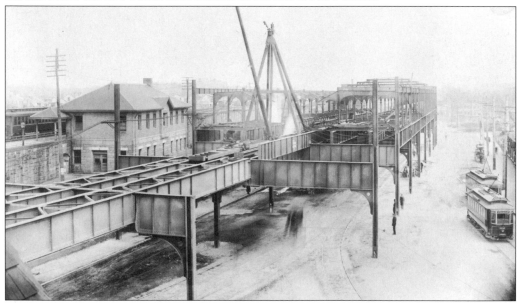

Shown is Forest Hills Square, looking northward almost a year later. The steelwork for the new El terminal is nearly complete, and on the left a commuter train is about to depart the Forest Hills Railroad Station for Boston. Also ready to go is the trolley car on the right, which took passengers to the Dudley Street Terminal and the North Station for only 5¢.

Two

TUNNELS UNDER DOWNTOWN

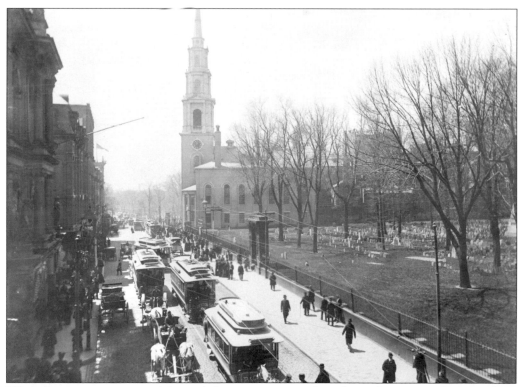

While Bostonians in general favored the construction of an elevated system in the city, there was strong opposition to locating elevated lines over the main shopping streets. One such street was Tremont Street, which is shown here in 1892 with the Old Granary Burial Ground and historic Park Street Church on the right and the Boston Common just beyond.

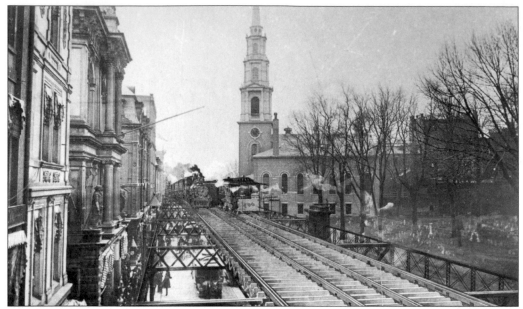

This view of the same section of Tremont Street is taken from a brochure published by the proponents of an elevated system. The photograph was doctored to show that an El structure over historic Tremont Street would not block out most of the sunlight. However, the city of Boston built a subway under Tremont Street that was later used by the El trains.

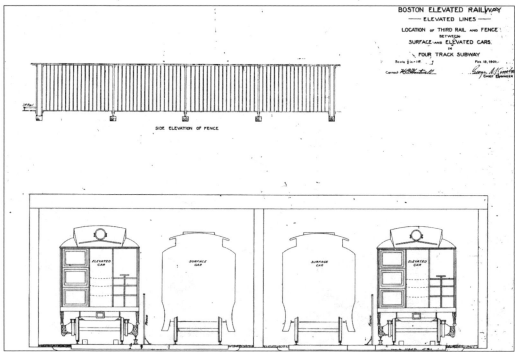

While designed and built for use by trolley cars, the Tremont Street Subway was used by El trains for eight years. This drawing shows the subway modifications required for train operation. The Atlantic Avenue Elevated Line, which skirted the downtown area, provided an alternate route across the city and enabled operation of a loop service in the downtown area.

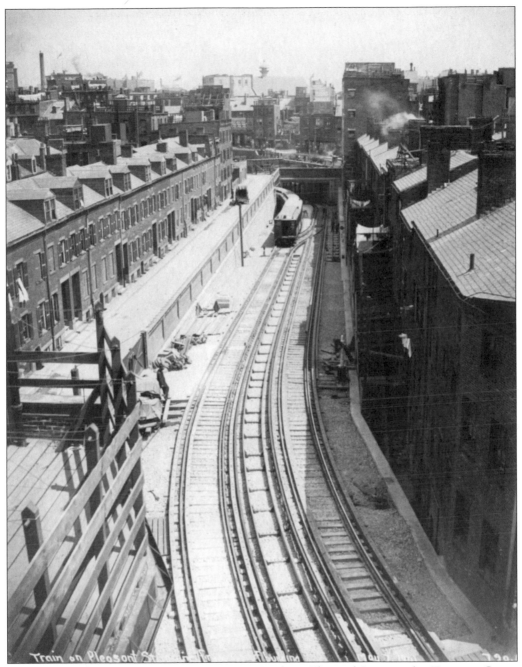

Train on Pleasant St.

In order to connect the Washington Street–Roxbury Elevated Line to the Tremont Street Subway, a long incline extending from the Pleasant Street entrance of the subway to Corning Street was built. The incline is seen in this view of May 7, 1901, looking toward Pleasant Street. Porter Street is on the left, where a row of brick dwellings was demolished to make way for the incline.

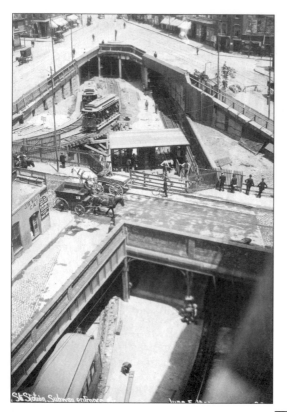

Shown in 1901 is the junction of Tremont Street, Shawmut Avenue, and Pleasant Street, with the entrance to the Tremont Street Subway in the center. Trolley cars were still using this entrance, as the new station for the El trains was being remodeled. Porter Street is at the lower left, above the standing El train.

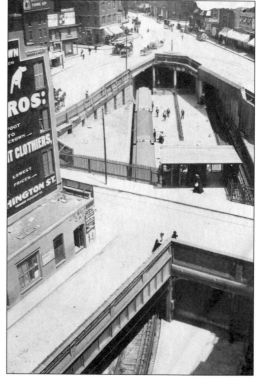

In this view of the same location on July 2, 1901, an El train is picking up passengers at the Pleasant Street Station. This section of the Tremont Street Subway still exists, although it has remained unused for 40 years. It extends all the way to Park Street Station and was being considered for use by the new Washington Street Light-Rail Line to provide a one-seat ride from Dudley Street to Park Street Station.

44

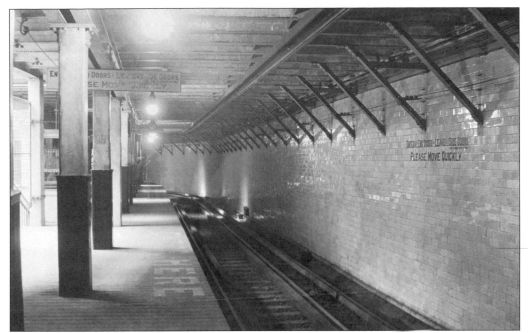

Among the changes required to adapt the Tremont Street Subway for use by the El trains was the installation of high-level platforms, a third rail, a signal system, and a new telephone system. Shown is the southbound platform at Park Street Station on August 2, 1901. Note the signs exhorting the passengers to move quickly.

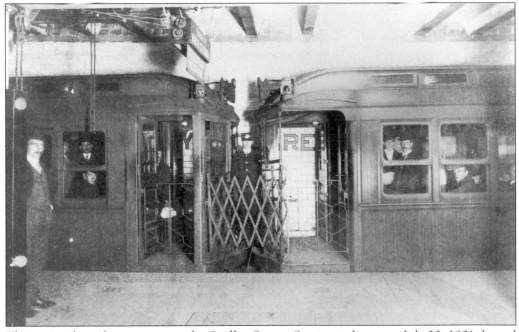

This train of wooden gate cars at the Scollay Square Station is shown on July 20, 1901, bound for Sullivan Square. The installation of rapid transit trains in the Tremont Street Subway was a remarkable accomplishment—carried out entirely by company engineering and construction forces in two months, a task that could not be duplicated today.

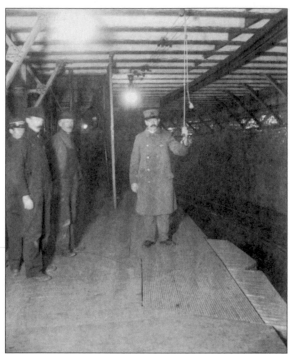

In order to compensate for the wide gap between the car sides and the platforms at stations located on curves, Boston Elevated Company engineers designed a system of sliding platforms that closed the gap. So practical was this system that it was copied by the New York Subway System.

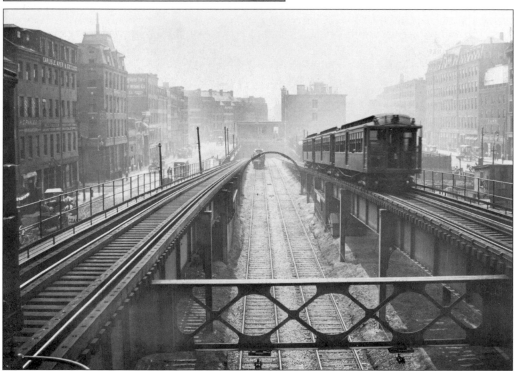

Looking from the North Station toward Haymarket Square on July 19, 1901, this view shows an El train descending from the elevated into the Tremont Street Subway and passing a trolley car headed for Union Square, Somerville. The building being erected atop the subway entrance is the Haymarket Relief Hospital, a downtown emergency medical center.

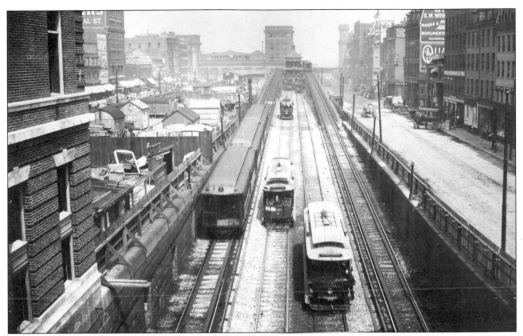

Looking in the opposite direction—from Haymarket Square toward the North Station—on the same day, this view shows the constant stream of trolley cars and El trains entering and leaving the subway. Haverhill Street is on the right, and the old North Union Station is in the distance.

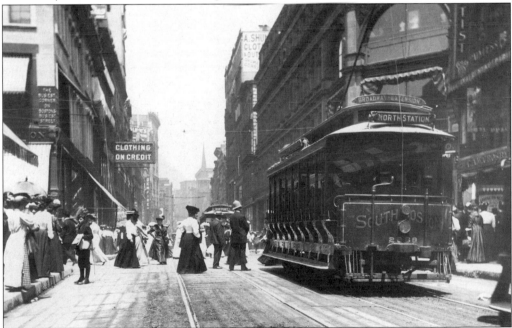

Looking northward along Washington Street at Temple Place in this June 26, 1905 view, subway construction is under way beneath the wooden planks, which are supporting the traffic. The open trolley is en route to the North Station from City Point, South Boston, and is passing the Jordan Marsh department store on the right. The steeple of the Old South Meetinghouse is visible in the distance.

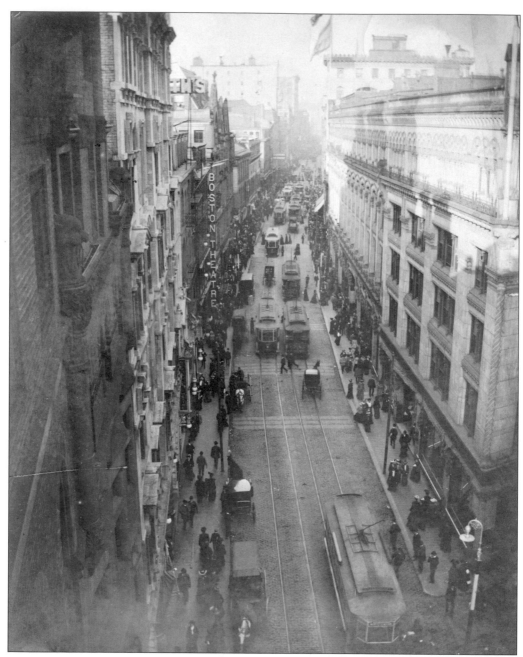

In 1902, the Boston Transit Commission and the Boston Elevated Company decided to construct a new subway under Washington Street from Broadway to Haymarket Square. The new line was intended for use by the elevated trains to enable their removal from the Tremont Street Subway, which was restored back to full trolley car operation. Shown is Washington Street, looking northward toward Summer Street, at 3:30 p.m. on October 12, 1903, when it was a center of shopping and entertainment for Bostonians.

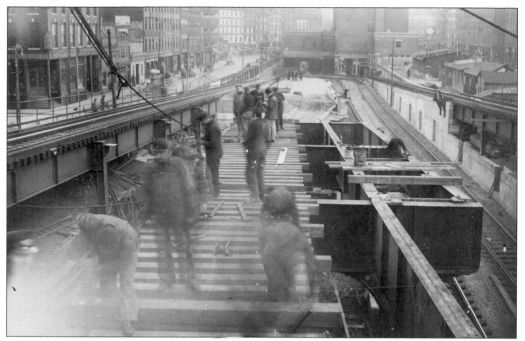

The new Washington Street Tunnel was connected to the Charlestown Elevated at Haymarket Square, seen in this November 3, 1908 view, looking from the North Station. The workmen are busy making changes to the El structure and tracks, which were required to divert the El trains from the Tremont Street Subway into the new Washington Street Tunnel.

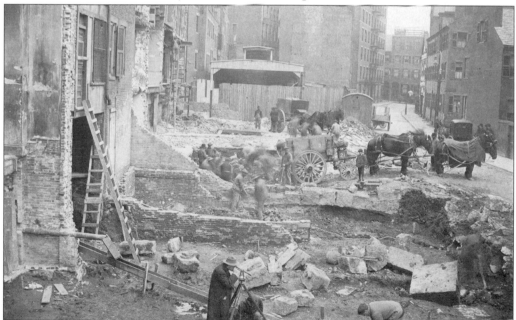

The South End of the new Washington Street Tunnel was connected to the Washington Street Elevated by a long incline near the junction of Broadway and Washington Street. The demolition of many buildings was required, including the Hotel Tivoli, seen in this view on April 8, 1908, with the new tunnel entrance behind the board fence in the center.

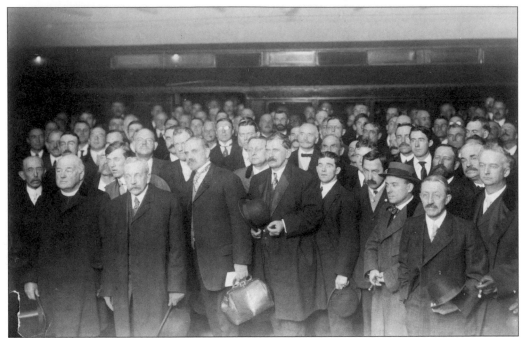

On November 23, 1908, the Boston Elevated provided an eight-car train of its brand-new steel cars to carry invited guests on an inspection trip through the new Washington Street Tunnel. Shown at the State Street Station are some of the notables and would-be notables who took part in the tour.

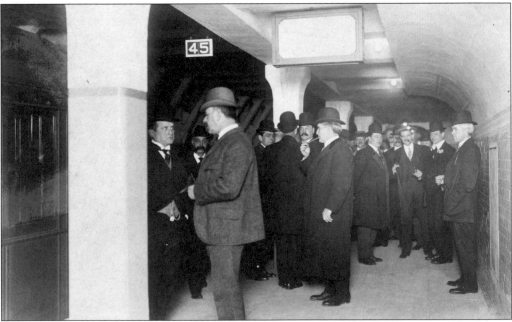

While the tour train was stopped at the Summer Street Station, two of Boston's most notable citizens engaged in conversation. The gentleman wearing the wing collar is John F. "Honey Fitz" Fitzgerald. He is conversing with Maj. Gen. William A. Bancroft, president of the Boston Elevated Railway Company.

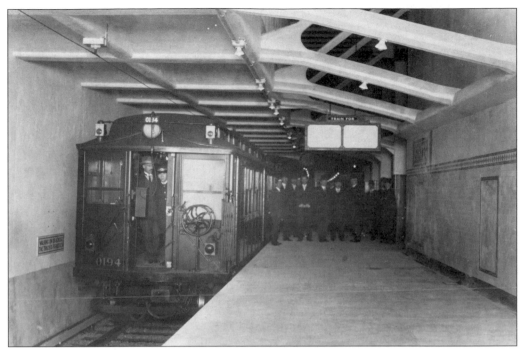

In this view, the special tour train is at the State Street Station, with No. 3-type Steel Car 0194 on the head end. More than 1,000 invited guests took part in the tour. Note the electric sign hanging from the girders that announced the destination of approaching trains.

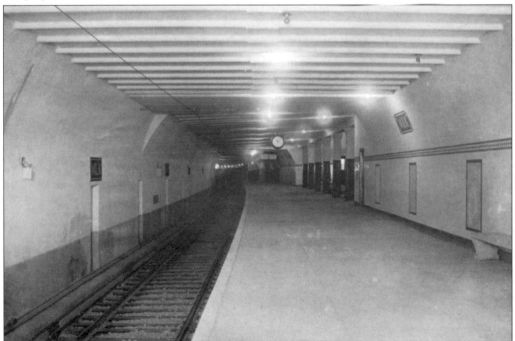

This photograph of the Milk Street Station in the Washington Street Tunnel was taken a few days before the tunnel opened to the public on November 30, 1908. Do not go looking for the Milk Street Station—it was renamed the State Street Station more than 30 years ago.

The Union Street Station of the Washington Street Tunnel was still in good shape—except for peeling paint—on June 27, 1963, when this photograph was taken, 55 years after the tunnel opened. The curious little boy on the left had better not lean over much farther.

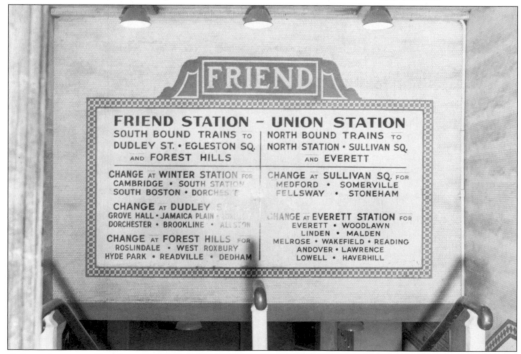

FRIEND STATION – UNION STATION

SOUTH BOUND TRAINS TO DUDLEY ST. • EGLESTON SQ. AND FOREST HILLS	NORTH BOUND TRAINS TO NORTH STATION • SULLIVAN SQ. AND EVERETT
CHANGE AT WINTER STATION FOR CAMBRIDGE • SOUTH STATION SOUTH BOSTON • DORCHESTER	CHANGE AT SULLIVAN SQ. FOR MEDFORD • SOMERVILLE FELLSWAY • STONEHAM
CHANGE AT DUDLEY ST. GROVE HALL • JAMAICA PLAIN • ROXBURY DORCHESTER • BROOKLINE • ALLSTON	CHANGE AT EVERETT STATION FOR EVERETT • WOODLAWN LINDEN • MALDEN
CHANGE AT FOREST HILLS FOR ROSLINDALE • WEST ROXBURY HYDE PARK • READVILLE • DEDHAM	MELROSE • WAKEFIELD • READING ANDOVER • LAWRENCE LOWELL • HAVERHILL

A longtime peculiar feature of the Washington Street Tunnel was the use of different names for the northbound and southbound platforms at each station. The Union and Friend Street Stations are now known as Haymarket Station.

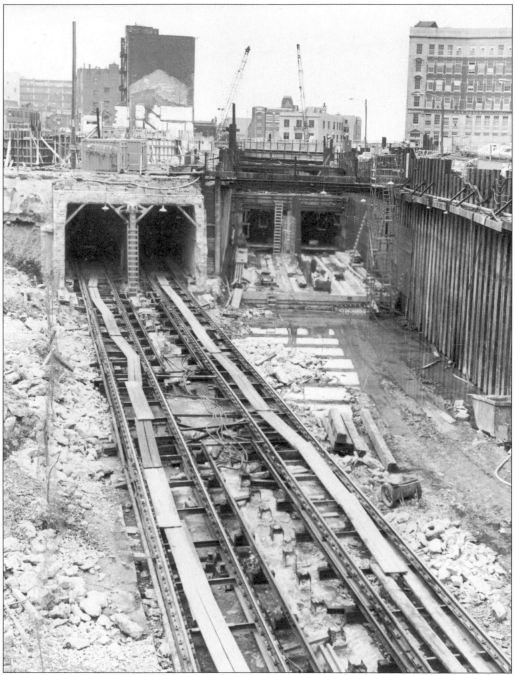

On the edge of Boston's Chinatown on October 5, 1972, construction work is under way to connect the Washington Street Tunnel to the new Southwest Corridor Orange Line. On the right is the Don Bosco High School, formerly the Brandeis Vocational High School.

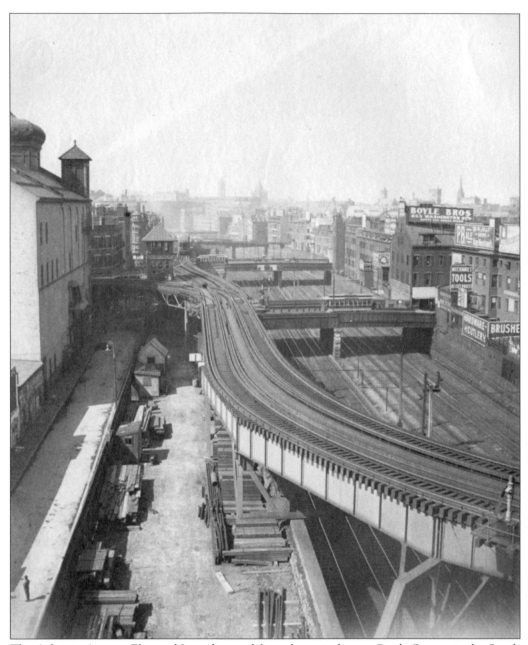

The Atlantic Avenue Elevated Line diverged from the main line at Castle Square in the South End and followed Harrison Avenue, Beach Street, Atlantic Avenue, and Commercial Street, rejoining the main line at Keany Square near the North Station. This view was taken on September 23, 1901, looking from Harrison Avenue toward Castle Square, with the Columbia Theater on the left.

Three

ALONG THE WATERFRONT, THE ATLANTIC AVENUE EL

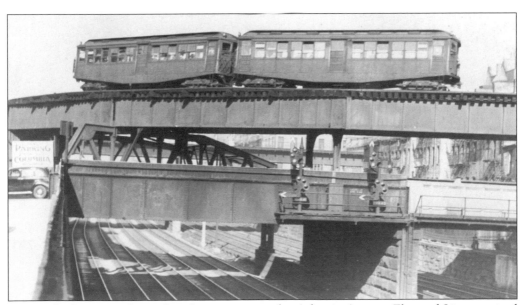

During the last several months of its operation, the Atlantic Avenue Elevated Line required only two car trains to handle the light midday riding. Shown is such a train approaching Harrison Avenue from Castle Square in June 1938.

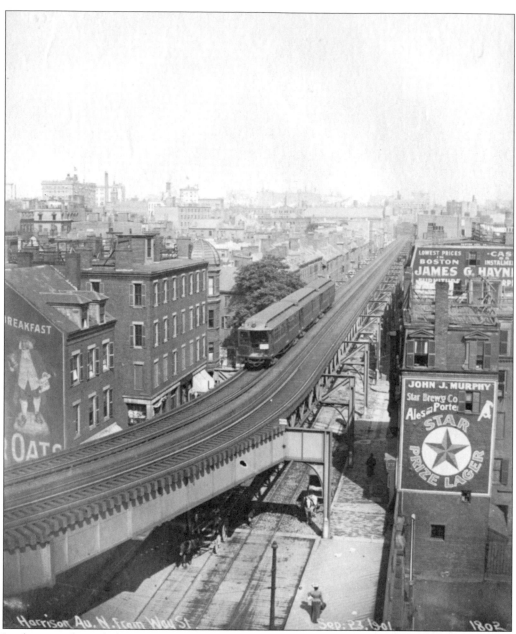

Looking northward along Harrison Avenue from Way Street on September 23, 1901, this view shows a train of wooden, open-platform gate cars headed for the Tremont Street Subway from Atlantic Avenue. This loop operation linked the waterfront with the downtown shopping district and was heavily used until it was discontinued in 1908, when the Washington Street Tunnel was opened.

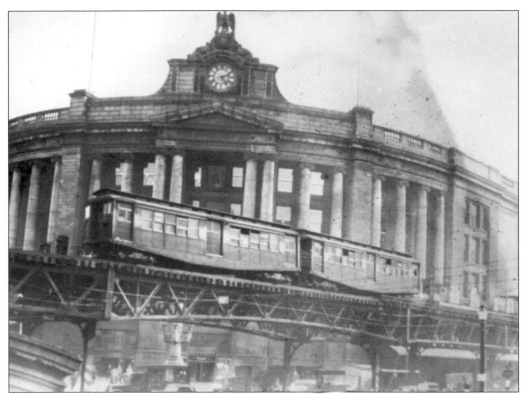

With the handsome façade of the South Station as a background, a train arriving from the North Station crosses above busy Dewey Square in June 1938. The Atlantic Avenue El was closed in October 1938 and was torn down in 1942, after much debate about resuming operation to meet wartime needs.

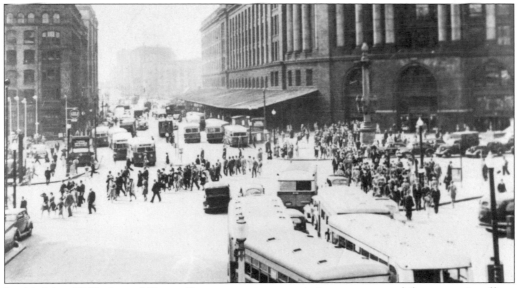

In this May 1943 view of Dewey Square, wartime restrictions on automobile use are in effect, and traffic in the square is dominated by buses, as hoards of rush-hour commuters stream out of the South Station to their downtown Boston jobs.

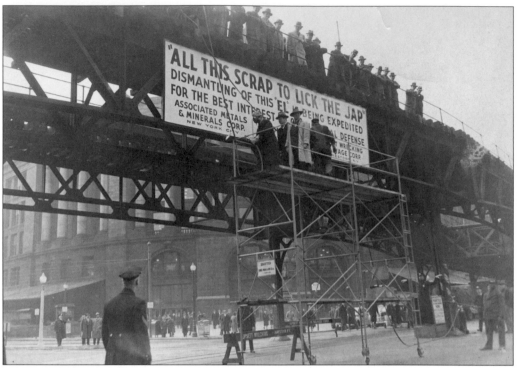

In an outpouring of patriotic fervor, Gov. Leverett Saltonstall wields a cutting torch to begin the dismantling of the Atlantic Avenue El in front of South Station on the morning of March 16, 1942.

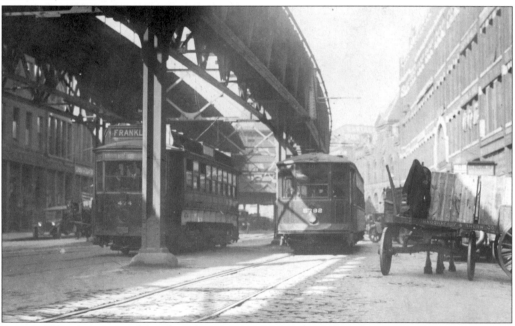

Rowe's Wharf was one of the three busiest stations on the Atlantic Avenue El, and it was also served by surface trolley cars running under the El from the South Station. This October 17, 1923 scene shows two trolleys passing, with Foster's Wharf and Rowe's Wharf on the right.

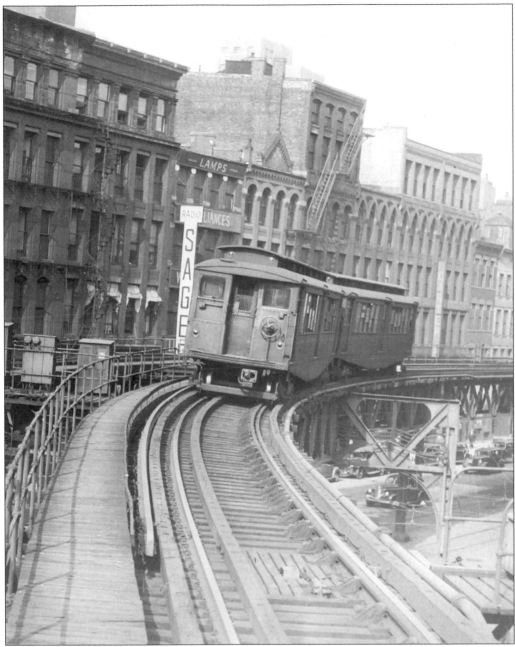

In this June 1938 view, a two-car train of No. 7 El cars has just left the South Station and is moving northward above Atlantic Avenue en route to the North Station. Along the route, riders had an excellent view of Boston Harbor and its busy shipping activity.

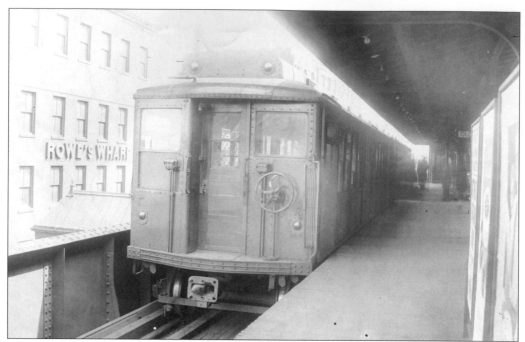

The heavy summer beach and steamer traffic has yet to begin as this train of No. 9-type El cars stops at a nearly deserted Rowe's Wharf Station on April 30, 1930. On busy summer days, more than 30,000 people passed through the turnstiles at Rowe's Wharf, and extra trains lined up to handle the heavy steamer traffic.

It is June 24, 1942 in this view, and both the El and trolley cars have vanished, although one track remains on Atlantic Avenue to serve the Union Freight Railroad trains linking the North and South Stations. Rowe's and Foster's Wharves are on the right, along with a Hayes-Bickford Cafeteria, one of a large popular restaurant chain that once served Bostonians.

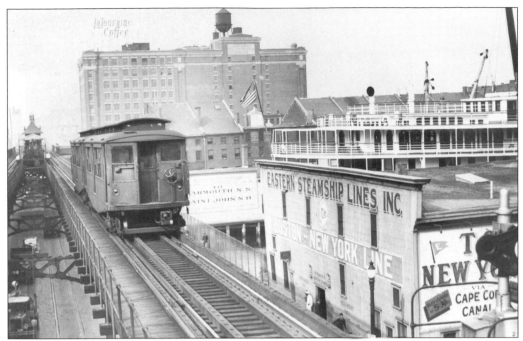

Looking north along the Atlantic Avenue El toward the State Street Station in September 1938, this view shows a train passing India Wharf. Also visible is one of the large white steamers of the Eastern Steamship Company, which provided overnight service between Boston and New York. At the adjoining dock, passengers boarded steamers bound for the Canadian Maritime Provinces.

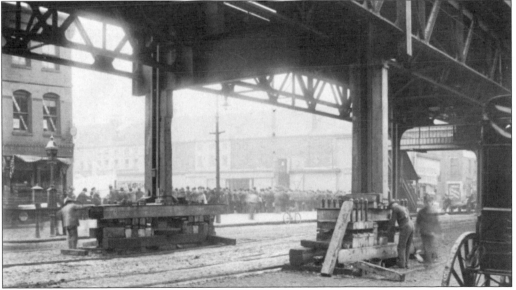

During the construction of the East Boston Tunnel in 1903–1904, it was necessary to shore up the Atlantic Avenue El at the point where the new tunnel passed from State Street under Atlantic Avenue and Long Wharf. In this June 24, 1903 view, workmen adjust the heavy supports for the El while a crowd of onlookers lines the sidewalk to watch something of interest in Boston Harbor.

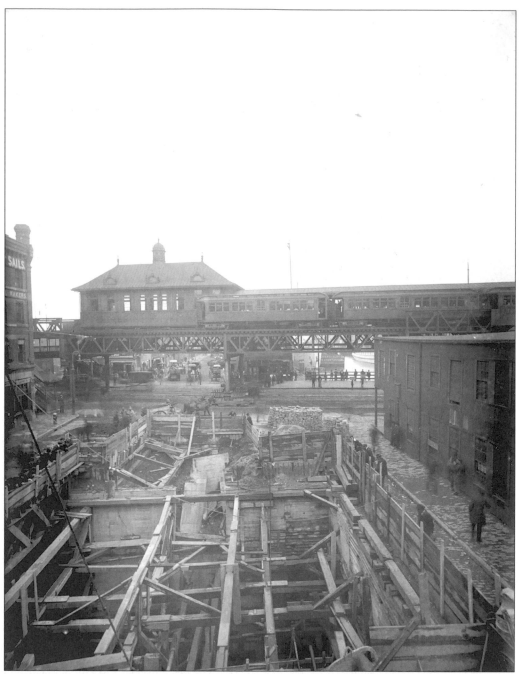

This June 23, 1903 view looks down State Street onto Long Wharf as a train of wooden gate cars stops at the State Street Station. The excavation in the foreground is for the East Boston Tunnel, which passed under Long Wharf and Boston Harbor to an entrance ramp in Maverick Square in East Boston.

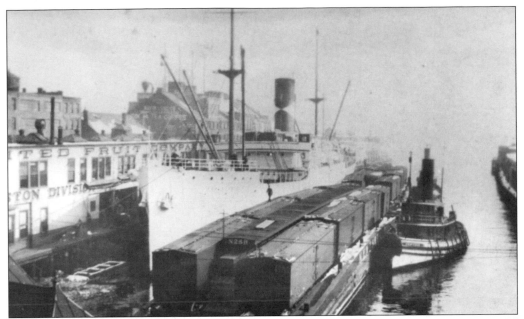

Among the interesting maritime activities that could be viewed from the Atlantic Avenue El was the arrival of the sleek white ships of the United Fruit Company, with their cargoes of bananas and other fruit. In this 1935 view taken from the State Street Station, the tug *Neptune* has positioned next to the steamer a car float carrying refrigerated freight cars, ready to unload the fruit into the rail cars.

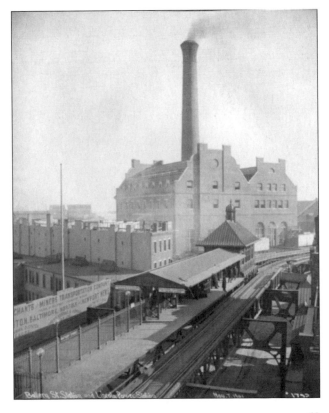

On November 7, 1901, both the new power station and the Battery Street Station of the El are completed and in operation. The power station, which was later enlarged, survived into the 1990s and is now the San Marco Condominiums.

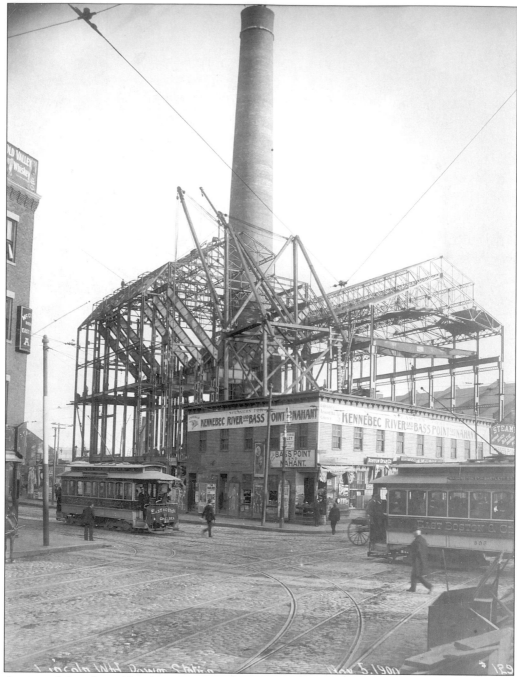

As part of the elevated railway project, the Boston Elevated Company acquired the Lincoln Wharf property on Commercial Street at Battery Street and erected a large power-generating station. This view taken from the corner of Battery and Commercial Streets shows work under way on November 5, 1900.

This April 1916 photograph, taken on the Atlantic Avenue El on Commercial Street, shows a North Station-bound train passing the infamous molasses tank of the Purity Distilling Company on the right. This may be the only known photograph of the tank taken prior to its disastrous collapse on January 15, 1919—an incident known as the Great Molasses Flood.

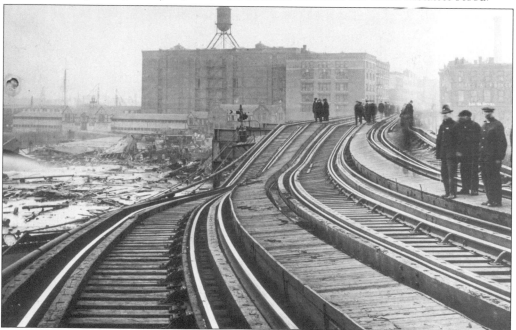

On the morning of January 15, 1919, the Purity Distilling Company's molasses tank containing 2.3 million gallons of the sticky liquid collapsed, sending a 20-foot wave of molasses and a large section of the steel tank slamming into the El structure on Commercial Street. Here, several hours after the accident, workmen survey the damage to the El and to the totally demolished buildings on the left.

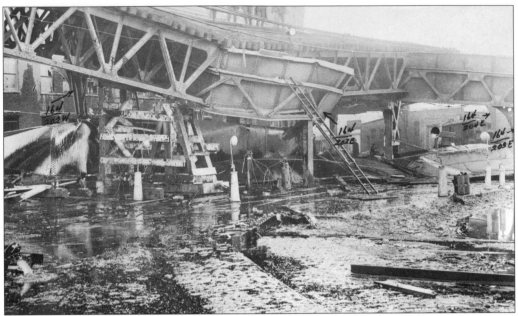

In this street-level view, workmen begin the removal of the twisted section of the molasses tank lying beneath the El. Residents of the first and second floors of the apartment house on the left were drowned when the sticky brown liquid surged through the windows. A total of 21 people were killed and 40 were injured, and dozens of horses were lost in the incident.

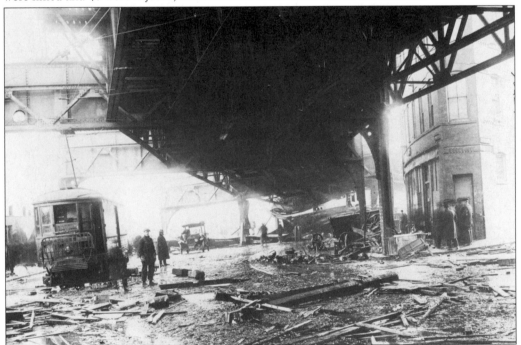

This view looking southward on Commercial Street shows the damaged section of the El structure with a twisted section of the molasses tank beneath it. Electric trolley freight car No. 38 on the left was smeared with molasses but was otherwise undamaged. This car finished out its days as a snowplow, clearing trolley tracks in Lowell until 1935.

When the Atlantic Avenue El was removed in 1942, the section from Keany Square to the old Trolley Express Station on Commercial Street was retained to store extra trains to handle crowds from events at the Boston Garden. This 1942 view shows the new end of the line, with the old freight terminal serving motortrucks. The apartment houses on the left, which withstood the molasses flood, are still standing today.

This view looking south on Commercial Street at Union Wharf on May 14, 1942, shows the dismantling of the Atlantic Avenue El. Eight complete sections of the El were saved and stored at the Charlestown Yard of the Boston Elevated Company to use as replacement sections in case the main elevated line suffered bomb damage from enemy air attacks—a real concern in 1942.

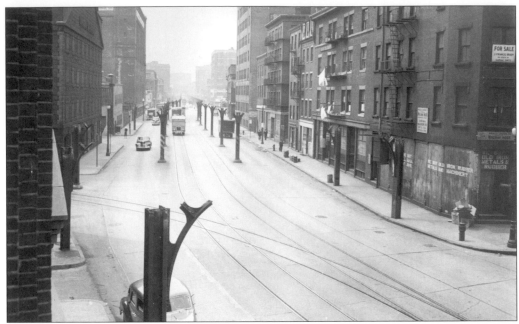

This view looks south on Commercial Street at the same location but several days later on May 25, 1942. Those are not trolley tracks in the street but the railroad tracks of the Union Freight Railroad, which provided a rail connection between the North and South Stations, as well as serving the docks and businesses along Atlantic Avenue and Commercial Street.

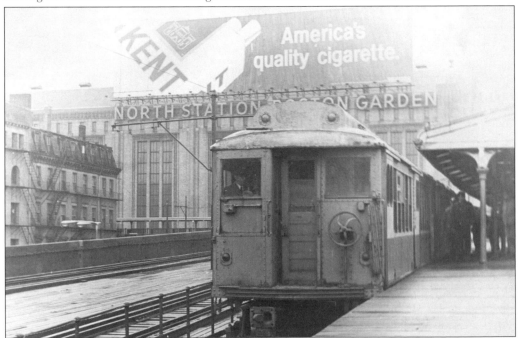

It seems like only yesterday that this Forest Hills-bound train of No. 10-type cars, wearing the tangerine and gray color scheme of the late 1950s, stopped at the North Station. However, nearly everything in this scene is now gone: the El, the North Station, and the Boston Garden. However, the mansard-roofed building on the left, the old Haymarket Hotel, still survives.

Four

THE CHARLESTOWN EL

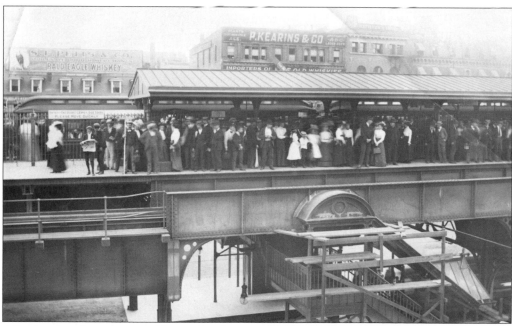

After leaving the subway at Haymarket Square, the North Station was the first station on the Charlestown Elevated Line. At 5:30 p.m. on August 27, 1901, the crowd awaiting a Sullivan Square train is quite properly dressed despite the heat—everyone is wearing a hat.

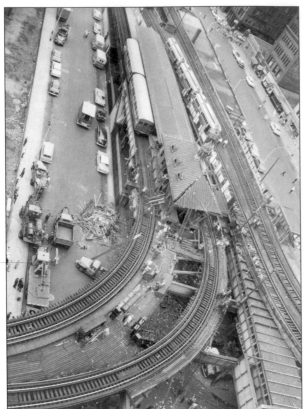

On the afternoon of June 11, 1959, a bomb left in a parcel locker in the North Station El Station exploded, damaging the station head house but causing no fatalities and only slight injury. This view was taken about an hour after the blast, and cleanup work was already under way so that elevated service to Charlestown and Lechmere Square could be resumed.

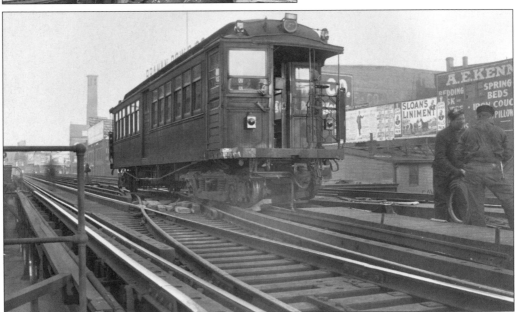

Fortunately, derailments on the El were rare, since the results could have proved disastrous. In this December 5, 1905 view, Wooden Gate Car 066 has derailed on the center track above Causeway Street. There is no delay to train service, however, and efforts to rerail the car are proceeding at a leisurely pace.

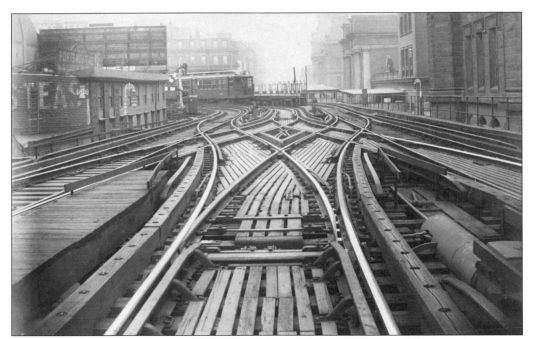

This 1911 view, looking westward along the Causeway Street section of the Charlestown El, shows the North Union Station of the Boston & Maine Railroad on the right and an Atlantic Avenue-bound El train at the sharply curved shuttle platform. The curved platform was used by the Atlantic Avenue trains from late 1908 to 1912, when a new shuttle platform was built as part of the Lechmere Square Elevated project.

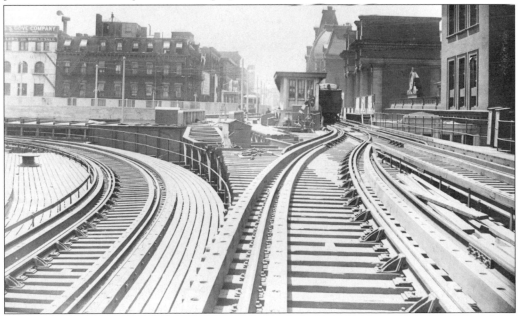

Another view of the same scene was taken on June 6, 1912. An Atlantic Avenue train is about to depart from the new shuttle platform on the just opened Lechmere Elevated Line. The steelwork and ties are in place for the never completed plan to run the El trains over the line to Lechmere Square, which opened using trolley cars on a temporary basis and still exists today.

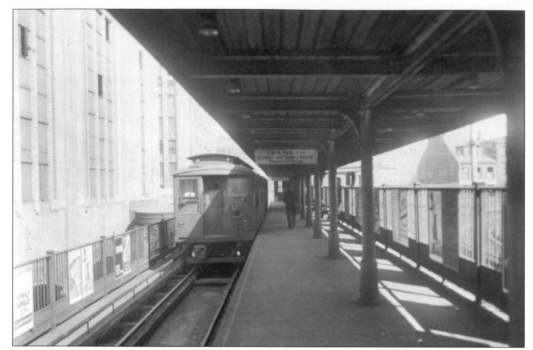

An Atlantic Avenue train awaits its departure time for the trip along the waterfront to the South Station, in this view from the shuttle platform at the North Station. On the left are the Boston Garden and the North Station, which opened in 1928 and were demolished in 1998, replaced by the Fleet Center.

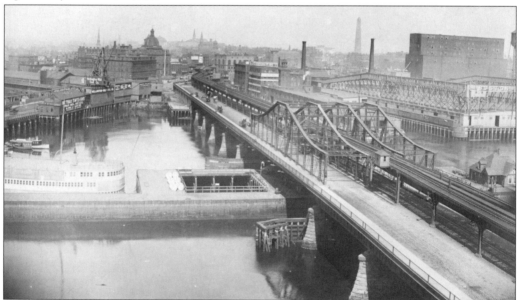

This panoramic view of Charlestown taken from the Boston side of the Charles River in 1911 shows the Charlestown El crossing the High Bridge with the Boston & Maine Grain Docks on the right. On the left is the Boston Floating Hospital, the white vessel moored in the foreground, which provided healthy sea air for ill underprivileged Boston children. Bunker Hill Monument can be seen on the skyline.

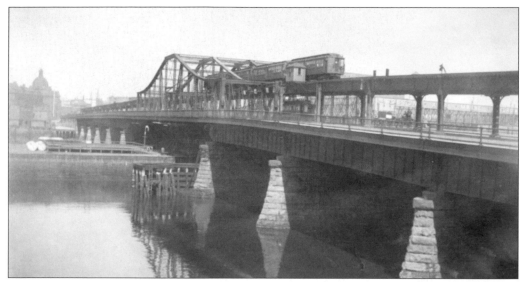

Another view from 1911 shows a Boston-bound El train passing over the 1,200-ton swing span of the High Bridge, which was completed in 1900. Although the Charlestown El is long gone, the bridge still serves as a vital link for motor traffic between Boston's North End and City Square in Charlestown.

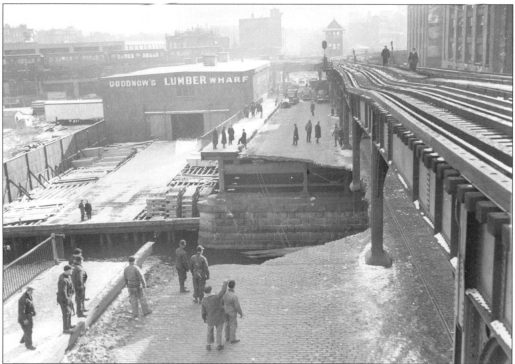

On the frigid morning of December 17, 1945, the cargo vessel S.S. *John Hathorne* fell victim to a tidal surge and rammed the Charlestown High Bridge while backing out of the Charlestown Grain Docks with a cargo for Naples, Italy. A portion of the roadway fell into the river, and the El structure sagged several feet, causing the bridge to be closed until emergency repairs could be made.

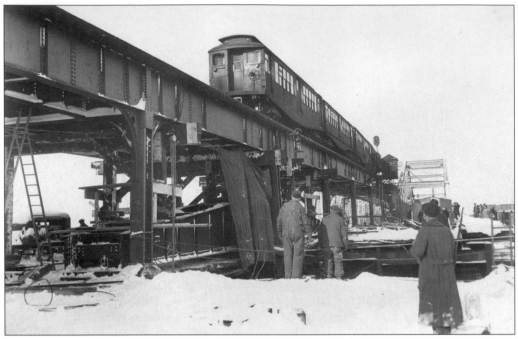

Within hours of the accident at the Charlestown High Bridge, the Engineering Department of Boston Elevated Company was at work on emergency repairs to enable the vital transit artery to reopen. The company borrowed a spare locomotive turntable from the Boston & Maine Railroad to support the El structure across the damaged portion of the bridge. Train service resumed at 11:15 a.m. on December 20, 1945, after 73 hours of around-the-clock work. Final repairs were completed on March 7, 1946.

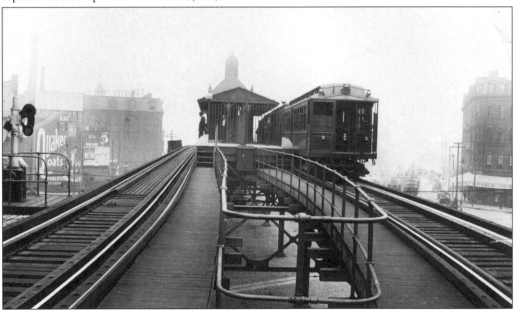

On August 15, 1901, this train of wooden gate cars stops at City Square Station in Charlestown. En route to Boston it must cross the High Bridge. Busy Warren Street, leading to the Warren Bridge with its heavy trolley and wagon traffic, is visible on the right.

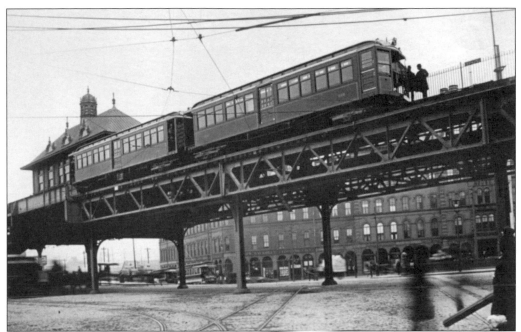

New red El Cars 014 and 018 pause at the City Square Station during an instruction trip for trainmen on the afternoon of April 11, 1901. The trip was held in preparation for the June 10, 1901 opening of the El system. The large building in the background is the Waverly House Hotel, a longtime City Square landmark.

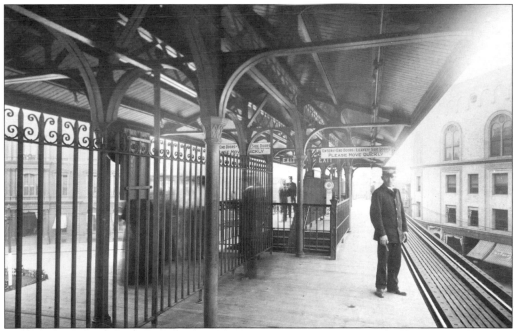

Standing on the platform at the City Square Station, a platform man holds the large key that was used to open the center doors on the gate cars before the invention of air-operated doors. Pictured on August 15, 1901, the City Square Station was built as a center platform station and was converted to a twin platform station in 1909 to handle the increasing ridership.

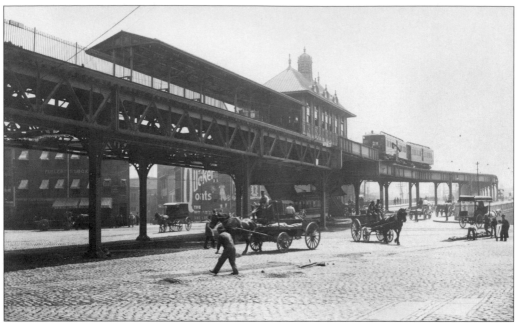

City Square is dominated by horse-drawn traffic in this view, looking southward toward the Charlestown High Bridge on May 31, 1901. The opening of the El system was just ten days away, and the El train leaving the station is being used to train the employees in preparation for the big day.

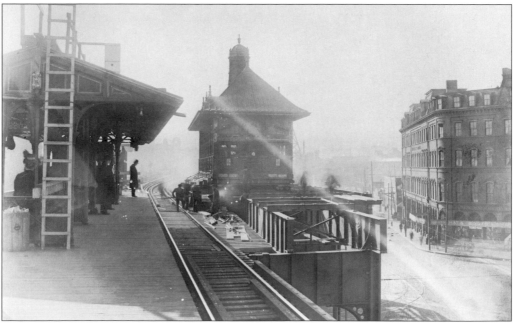

By March 15, 1909, work was under way to install a second platform at the City Square Station. The project took three months and was carried out without any interruption to train service. In this view, the original station head house has been raised and moved across the southbound track to its new position on the future southbound platform, for which some of the steelwork is already in place.

76

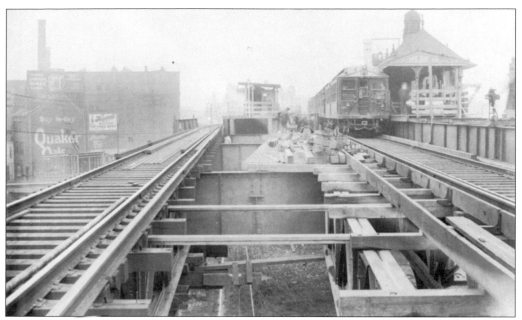

In this April 21, 1909 view of the City Square Station, the new southbound platform is coming along well, as workmen prepare to relocate the northbound track on the left to make room for a new northbound platform. Note the train of wooden former gate cars, which are now equipped with enclosed ends and air-operated doors.

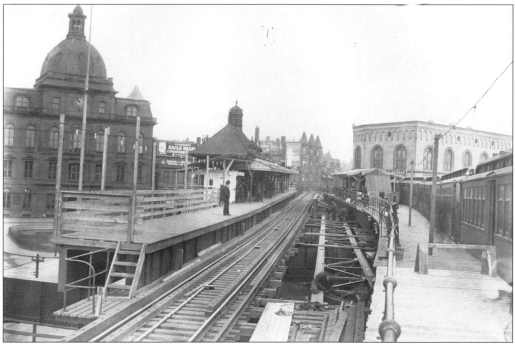

In this view of the City Square Station, the southbound track and platform are nearly complete and in use, while workmen prepare the steelwork for relocation of the northbound track. The train on the right is bound for Sullivan Square on the old northbound track, which was removed shortly afterward.

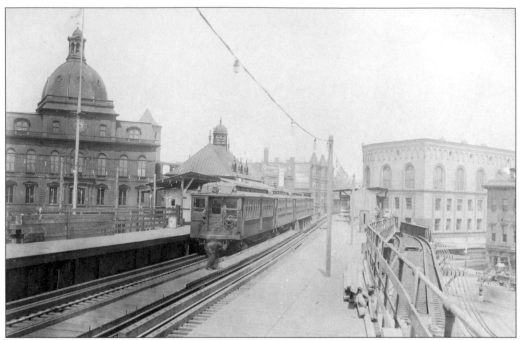

By April 27, 1909, the major reconstruction work at the City Square Station has been completed, except for the erection of a new head house on the northbound platform—a duplicate of the older head house now located on the southbound platform. The train of wooden cars is headed for Boston.

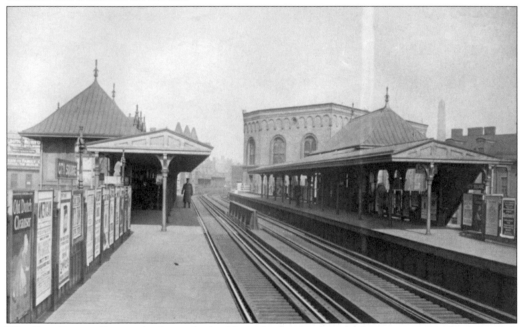

The City Square Station looks as if it had been built as a two-platform station, in this March 8, 1910 view. In a job well done, the Boston Elevated Company went to great lengths to make sure that all the architectural elements and style of the new northbound station conformed to the original 1901 designs by Alexander Wadsworth Longfellow.

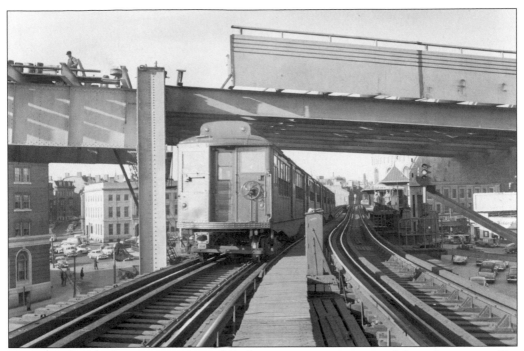

Some people felt that Boston Elevated Railway structures were unsightly and intrusive. For other people, however, the new generation of overhead highways proved to be far worse. This December 4, 1952 view shows work under way at City Square on the overhead highway linking the Mystic River Bridge to Boston's new Fitzgerald Expressway.

While the Washington Street Elevated was virtually straight from Castle Square to Forest Hills, the Charlestown El had a number of rather sharp curves, such as this one at Henly Street, just north of City Square. This train heads for Sullivan Square on November 1, 1949.

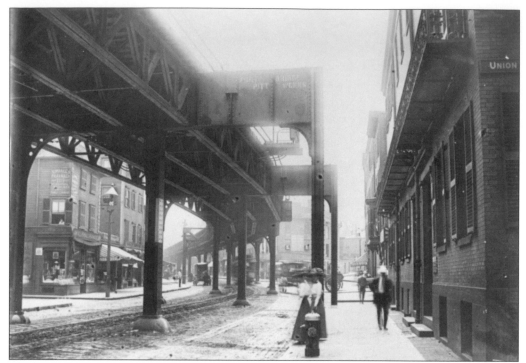

The section of Main Street in Charlestown between Thompson Square and City Square is rather narrow and curvy, as seen in this early 1901 view. There was only room for one trolley track under this section of the El, which was used by only southbound cars.

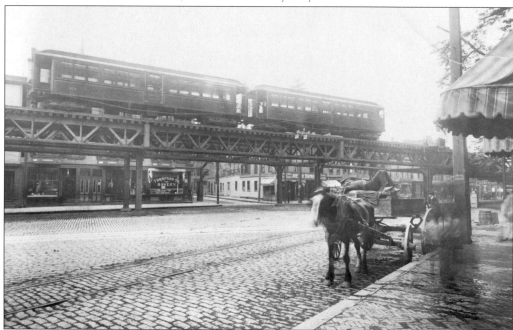

As originally opened, the Charlestown Elevated did not have a station at Thompson Square. This train passes through the square at the site where the Thompson Square Station was later built. Notice the obviously tired fellow napping on the seat of the wagon in the foreground.

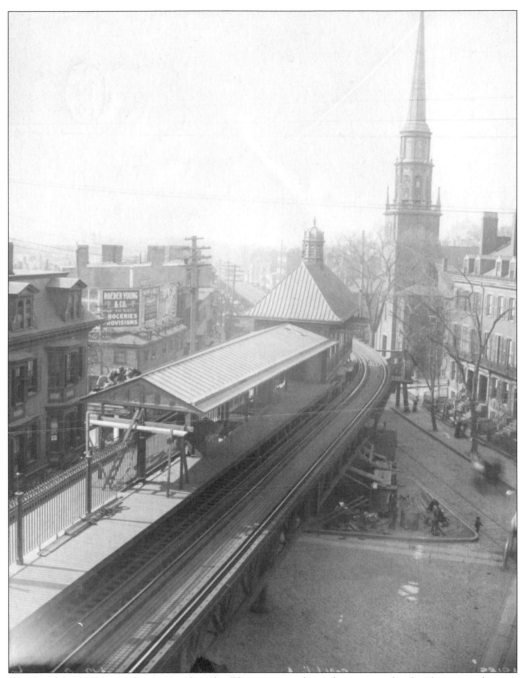

On April 1, 1902, nearly a year after the El was opened, workmen put the finishing touches on the Thompson Square Station. After the Charlestown El closed in April 1975, this station was lowered to the ground for use as a restaurant near the square. The building later burned in a fire of suspicious origin.

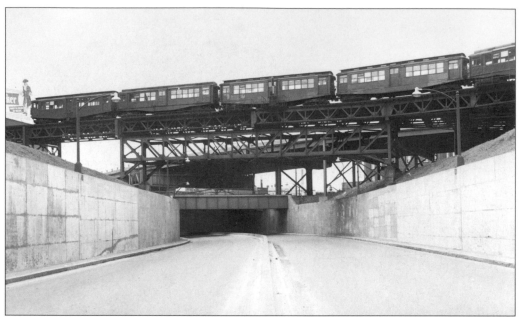

By the mid-1950s, the Sullivan Square area had become a maze of highway underpasses and overpasses. In this April 8, 1957 view, a Boston-bound train passes over some of the recently completed highway work. Two of the cars in the train are now stored in a railway museum.

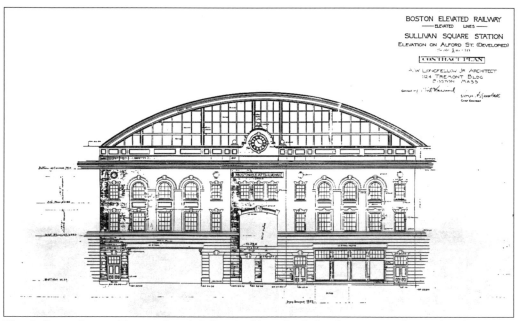

The Sullivan Square Terminal and Office Building, built for the Boston Elevated Railway, was certainly one of the handsomest public transit structures to be built in the United States. Designed by Alexander Wadsworth Longfellow, the building combined the best elements of form and function.

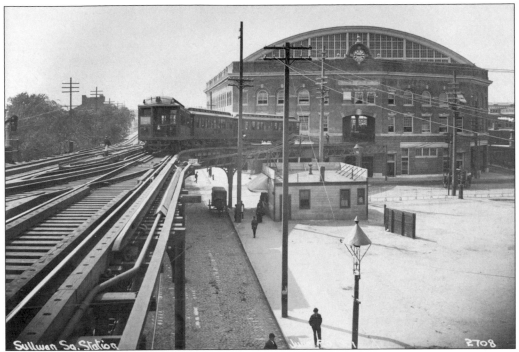

A train of gate cars from Boston is about to enter the Sullivan Square Terminal Building on June 20, 1901. In its original form, the station contained ten tracks for surface cars and one elevated track for the El trains, which looped around the building for the trip back to Boston. The lower level contained a double-track loop for surface cars.

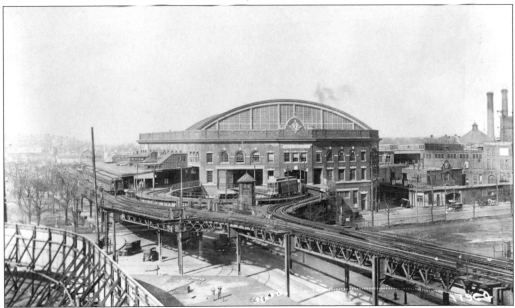

This March 1923 view shows the terminal as it looked after major alterations were made in 1912. These alterations included the construction of a new inbound loading platform for El trains on the west side of the building, as well as a new loop for surface cars. The planned extension to Everett, as well as increased traffic, made these additions necessary.

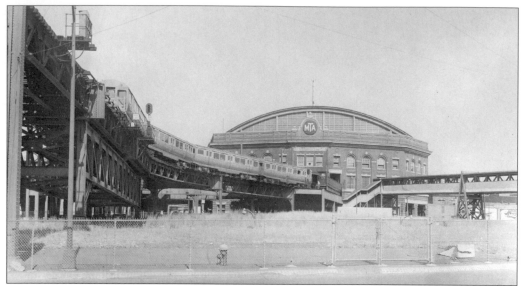

On August 7, 1957, a train of new No. 11 El cars enters the Sullivan Square Terminal beneath the big clock face, which has been covered by an MTA emblem. By the mid-1950s, Sullivan Square on the south side of the terminal and the park on the west side had been obliterated by a maze of highway overpasses and underpasses.

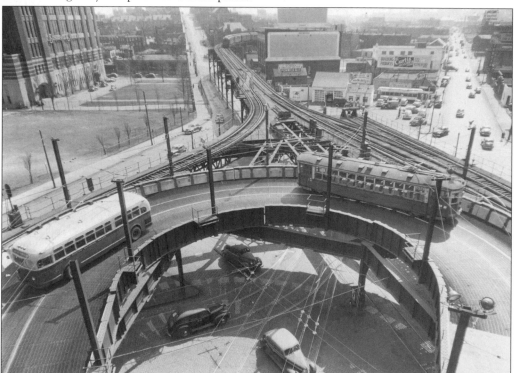

This view of Sullivan Square was taken from the third-floor offices of the El in the Sullivan Square Terminal Building on March 23, 1947. A motor bus and trolley are moving along the upper-level loop as an El train heads for Boston along the line above Main Street. Bunker Hill Street climbs to the left. Rutherford Avenue, lined with dairy plants, stretches off to the right.

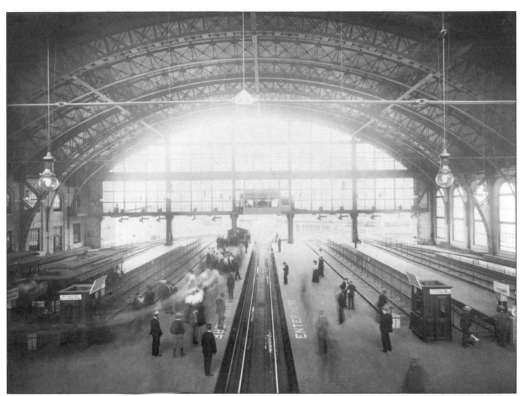

The interior of the big train shed at Sullivan Square is shown during a quiet moment on August 13, 1901. The view was taken from the office level of the terminal building. The signal booth located above the center track controlled all train and trolley car movements in and out of the upper level of the terminal.

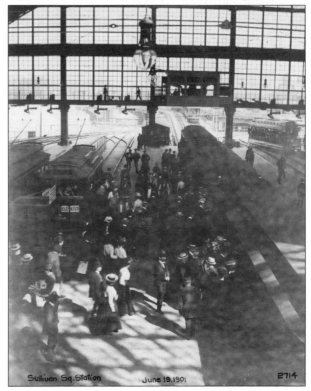

A similar scene shows crowds boarding a train for Boston, as heavily loaded open trolleys enter and leave the terminal on June 19, 1901. Trolleys for Arlington, Medford, and Somerville used tracks on the left; Everett and Malden cars departed on the right. Cars for Boston and Cambridge used the lower level.

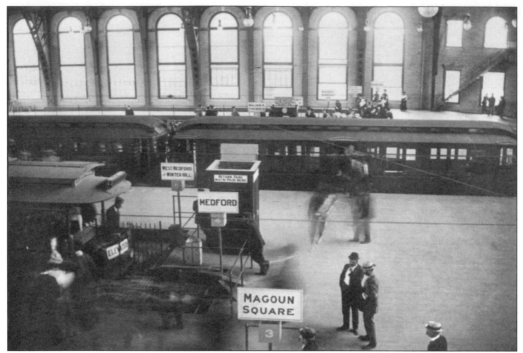

The design of the Sullivan Square Terminal stressed openness, airiness, a lack of clutter, and ease of transfer. Passengers transferring between El trains and surface trolley cars simply walked a short distance across the platform; they did not have to use stairs, escalators, or elevators—necessary in most of the newer stations built since 1964.

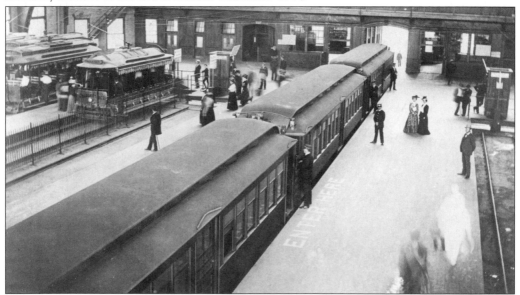

Everything is functioning quite smoothly in this view of the Sullivan Square Terminal, taken on July 26, 1901, six weeks after the new El system began operation. The Boston Elevated Company made a great effort to integrate the El lines into Boston's transit system. On opening day when 51 trolley lines were rerouted to serve the El, an army of 1,500 men was stationed on the streets to guide the public.

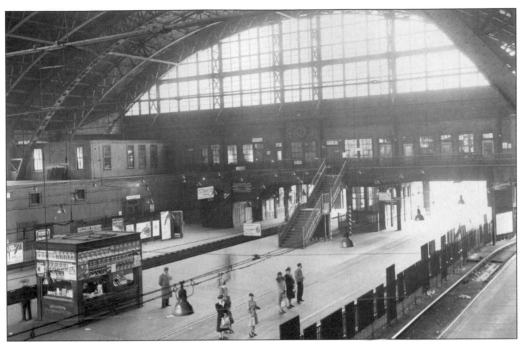

Not only was the terminal a major transit center, it also housed the offices of many departments of the Boston Elevated Company, some of which are visible in this October 11, 1945 view. Located in the terminal were the offices of the Elevated Division, Signal, Employment, Medical and Timetable Departments, as well as a restaurant, a barbershop, and several small stores.

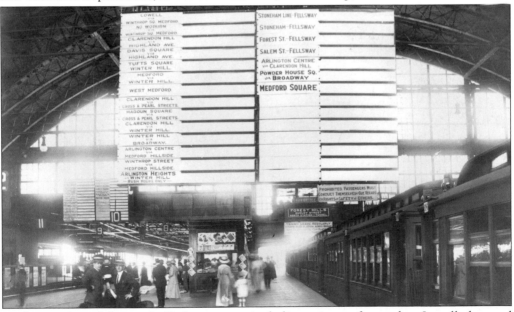

Trolley cars bound for nearly 20 destinations, including points as far north as Lowell, departed from the West Platform, or Medford Platform, on the upper level of the terminal. The starting point for cars to Malden, Everett, and Maplewood was the East Platform, or Malden Platform, visible on the right behind the El train. Cars for Cambridge, Charlestown, and Boston left from the lower level of the station.

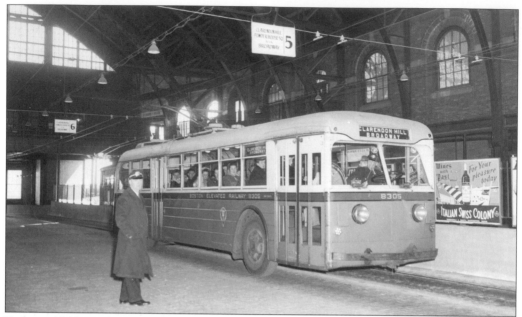

Early in 1946, as electric trolleybuses began to replace trolley cars and motor buses on many routes, the upper level of the terminal was renovated to accommodate the rubber-tired vehicles in addition to the trolley cars. In this December 11, 1946 view, one of the swift smooth-riding trolleybuses is about to depart for Clarendon Hill in Somerville.

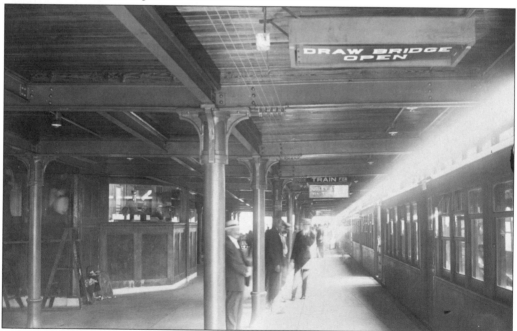

This view shows the recently opened southbound El platform at Sullivan Square on September 4, 1912. A train is ready to depart for "Dudley Street via Tunnel" as soon as the rather loud departing gong sounds. The train master's office is on the left. Note the "Drawbridge Open" sign on the ceiling, which was lowered to advise riders of delays caused by opening of the Charlestown Drawbridge.

On April 14, 1901, a train of newly equipped El cars is ready to leave Sullivan Square on a test run. Leaning out of the cab on the left is George Cornell, chief engineer of the Brooklyn Union Elevated. On the front platform, from left to right, are conductor Nelson Towle, superintendent Stuart S. Neff, and inventor and engineer Frank J. Sprague. On the station platform is head janitor Thomas Daily.

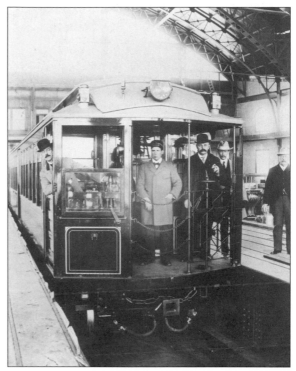

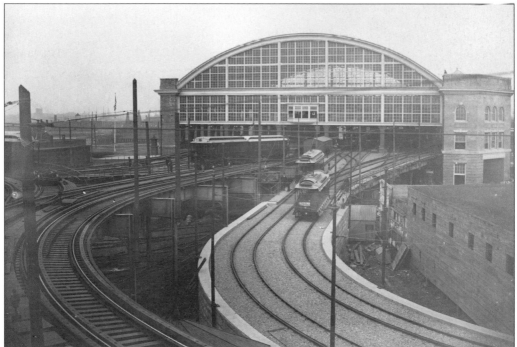

El trains and trolley cars enter and leave the Sullivan Square Terminal during practice operations held before the June 10, 1901 opening of the Boston Elevated Railway. Nearly two months of intense training and practice resulted in a smooth opening day, which was marred by only few minor problems. This view of the terminal's north side was taken on May 15, 1901.

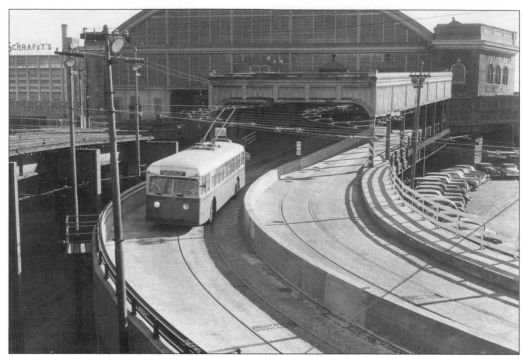

This view shows the north side of the terminal nearly half a century later, on December 11, 1946. The ramp leading to the upper level has been widened and paved to allow trolley and motor buses to use the upper level along with the trolley cars. The trolleybus moving down the ramp is bound for Clarendon Hill and Broadway in Somerville.

Looking only slightly shopworn after 50 years of heavy use, the lower level of the Sullivan Square Terminal retains evidence of the high quality of construction that went into the structure. The white tile, glazed brick, and polished brass still look elegant in this June 22, 1949 view. The trolley car and Ford bus on the left served the local Charlestown riders.

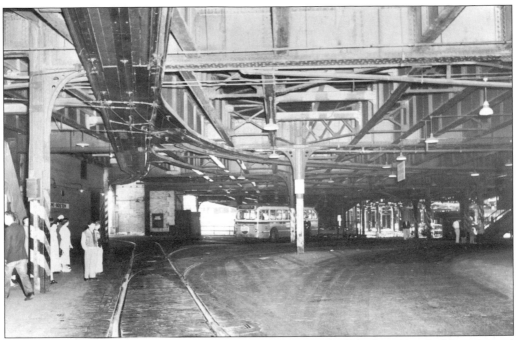

During a quiet moment in the spring of 1950, this photograph of the lower level of the terminal was taken. The lone motor bus in the center is about to depart for Haymarket Square in Boston via Bunker Hill Street.

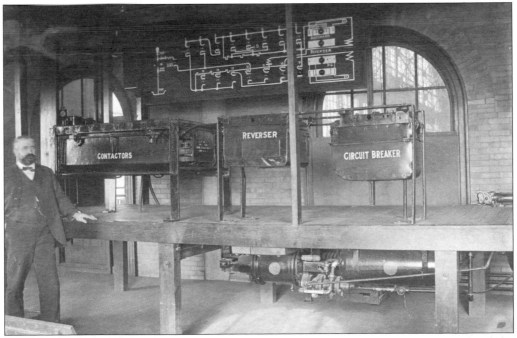

Hidden away in the upper-level office area of the terminal was the instruction school for Elevated Division trainmen. In well-equipped classrooms, newly hired trainmen were introduced to the electrical-control and air-brake systems of the trains. Older employees underwent annual refresher courses to keep them up-to-date on any equipment changes.

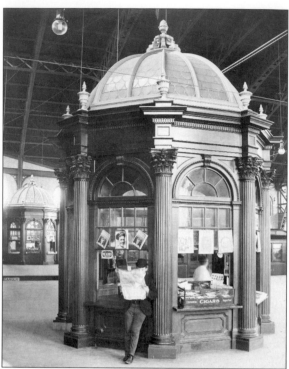

Even the candy stands and newsstands in the terminal's upper level exude elegance, as seen by these two well-stocked stands, which are a symphony in polished mahogany, brass, and leaded glass.

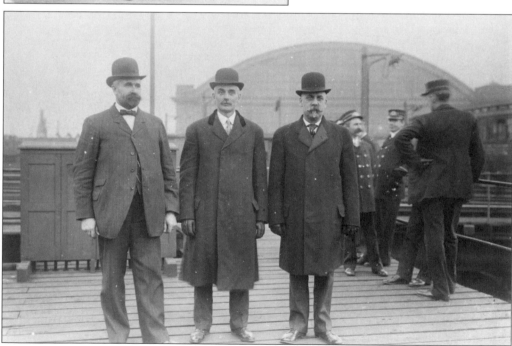

On a bright spring morning in April 1902, the company photographer recorded the visit of a London Metropolitan Underground Railway official, who toured Boston's transit system. At the Sullivan Square Terminal, the official stands in the center, flanked on the left by George Benjamin, train master of the El Division, and on the right by H.A. Pasho, general superintendent of the Boston Rapid Transit System, a post he held for 33 years.

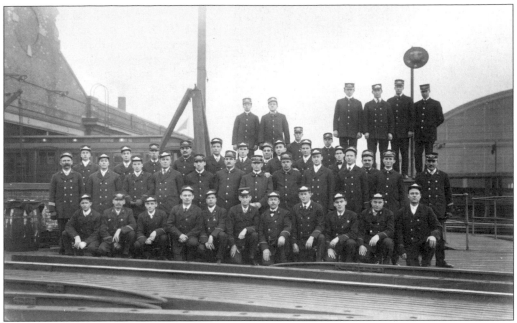

Not to be left out of the picture by any means are the men who ran the trains and supervised the stations. To be assigned to the Elevated Division was considered an honor, since only those men with spotless records and obvious ability were qualified to work on the trains.

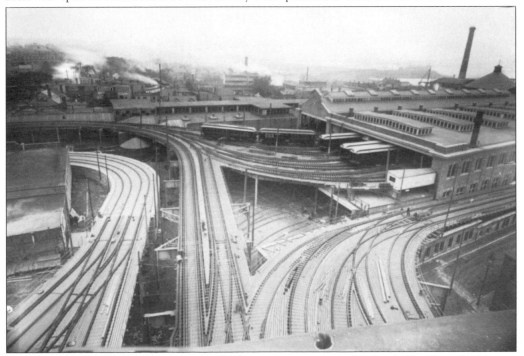

Located immediately behind the Sullivan Square Terminal, the big brick Car Shop Building is pictured from the roof of the Terminal Building. A two-story structure, the shop maintained El cars on the upper level and surface trolley cars on the lower level. Considered the most modern facility of its type when it opened in May 1901, the shop remained in use until April 1975.

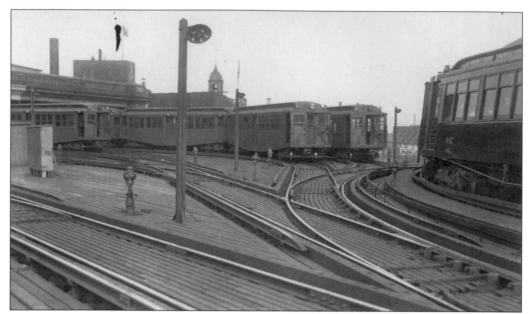

In this April 1916 view, an assortment of wooden and steel El cars stand in front of the Sullivan Square Car Shops, awaiting the call to afternoon rush-hour duty. On the right, a train loops around for the trip from Charlestown to Boston and Roxbury.

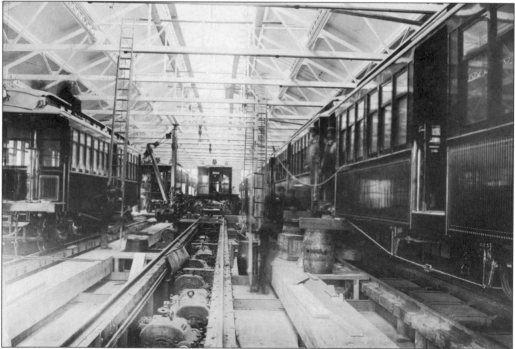

When the Boston Elevated Railway's fleet of new El cars was delivered in the spring of 1901, the final assembly of the cars was carried out in the company's own new shop, which was still in the process of being completed. This view shows the interior of the Sullivan Square Shops on March 8, 1901. Lines of new El cars are having their motors installed along with their control and braking equipment.

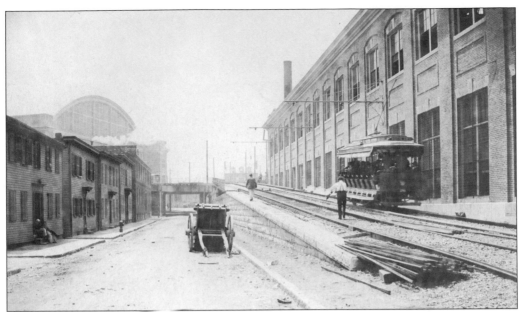

This view of Beacham Street looks eastward toward the Sullivan Square Terminal, which looms in the left background. The brick building on the right is the Elevated Car Repair Shop. An open trolley from Woodlawn in Everett ascends the ramp to the Elevated Terminal. Irish immigrants, many of whom found employment with the Boston Elevated Company, occupied most of the wooden tenements on the left.

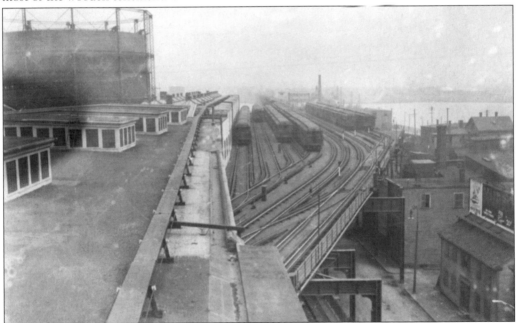

In this March 1919 photograph, taken looking westward from the Sullivan Square Terminal toward Everett, Beacham Street has largely vanished under a new Elevated Car Storage Yard, which casts its shadow on the tenement houses on Beacham Street. The Charlestown Gas Works, seen on the left, was later taken over by the Boston Elevated Company to permit further expansion of its Charlestown Maintenance Facilities.

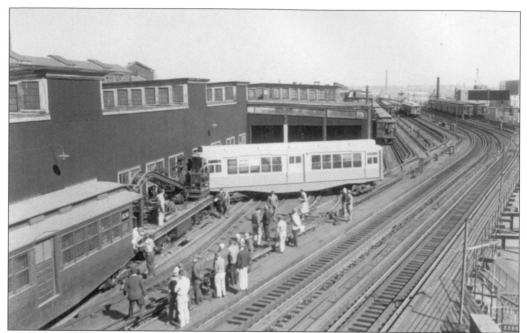

Derailments on the El lines fortunately were a rarity and usually of a minor nature, such as this one on October 3, 1957, when Passenger Car 01000 derailed in front of the Sullivan Square Shops. The wreck train, consisting of Car 0210 and Crane Car 0504, quickly remedied the situation. All three cars in this scene are currently stored in a railway museum.

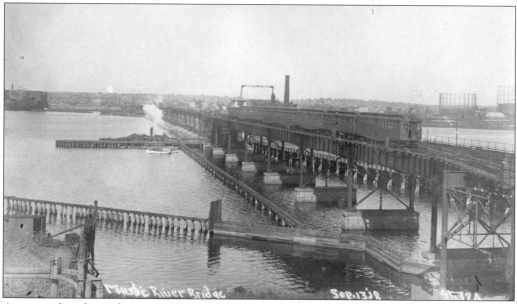

As part of a planned extension of the Charlestown Elevated from Sullivan Square through Everett to a large terminal near Malden Square, the Boston Elevated Company built a costly El structure and drawbridge across the Mystic River to Everett, where a "temporary" terminal was built. In this September 1918 view, looking toward Everett, the Monsanto Chemical Plant is on the left and the big Eastern Gas & Fuel Plant on the right. Those industries, along with the El line, are now just memories.

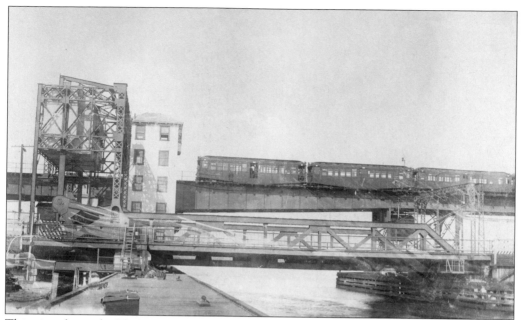

This view shows the El's Mystic River drawbridge, with a mixed train of steel and wood cars on a break-in trip on March 12, 1919, three days before the line opened for revenue operation. The Alford Street drawbridge is in the foreground.

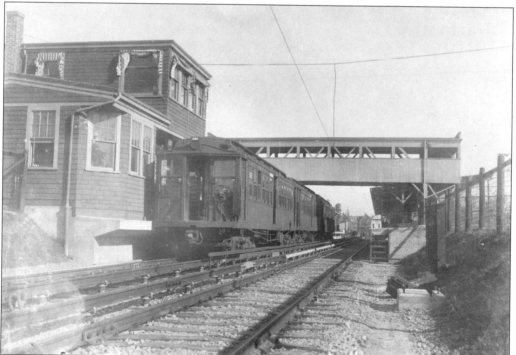

On October 24, 1918, an instruction train for employees sits in the nearly completed Everett Station. The station is not up to the Boston Elevated Company's usual standards of design and construction since it was meant to be only a temporary one. The station always had a rather shabby atmosphere, with its wood clapboard style of construction.

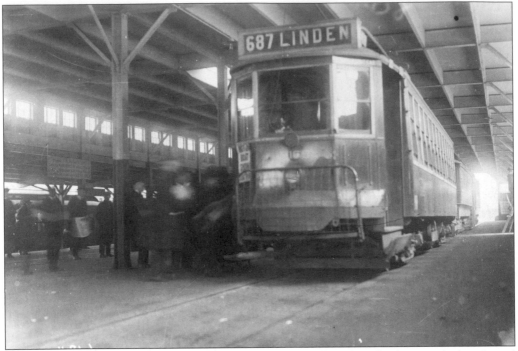

Despite its temporary nature, the Everett Terminal was able to handle the crowds that flowed through it to all points in the cities of Everett and Malden. This March 29, 1920 scene shows passengers who have just arrived on a train from Boston rushing across the platform to board a waiting trolley for Linden, a section of Everett.

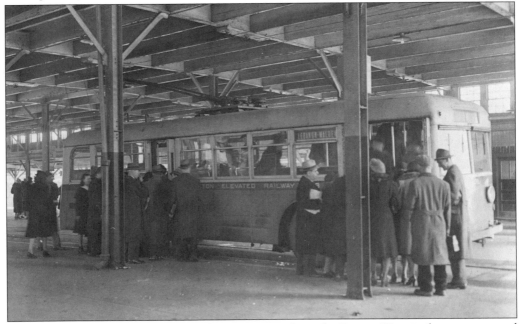

Beginning in 1937, all the trolley car lines operating from the Everett Terminal were converted to trolleybus operation. This December 1941 scene at the terminal shows homebound commuters boarding one of the quiet and fast electric trolleybuses for Lebanon and Malden.

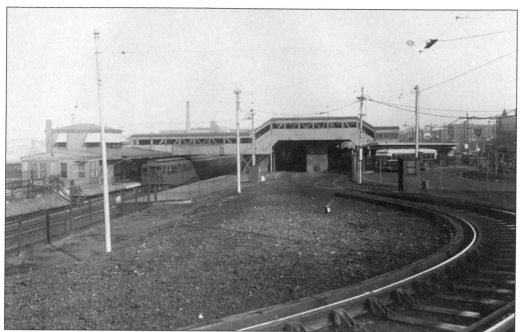

This general view of the West End of Everett, taken on December 29, 1932, shows an El train on the left about to leave for Boston and an Eastern Massachusetts Street Railway bus on the right ready to head for Haverhill. The Everett Terminal was the only major transit terminal on the Boston Transit System that was constructed entirely of wood.

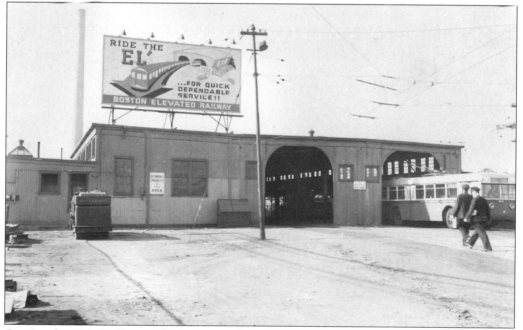

On October 16, 1947, a trolleybus exits the Everett Terminal, which is showing its age. A rooftop billboard exhorts motorists to park at the terminal and take the El downtown. In the 1930s, the Boston Elevated Railway began providing parking for transit riders—now a nationwide practice of transit systems.

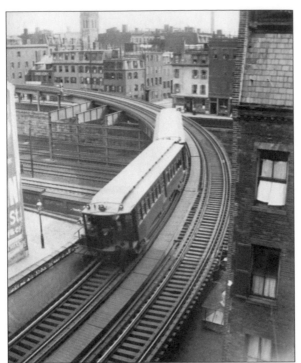

After leaving the Tremont Street Subway at Pleasant Street, Dudley Street-bound El trains climbed a grade and crossed the right-of-way of the New Haven and Boston & Albany Railroads on a high curving trestle to reach the Washington Street Elevated at Castle Square. This June 5, 1901 view shows a train crossing that section of line, which required removal of two of brick the row houses, which were to the left of those seen in the foreground.

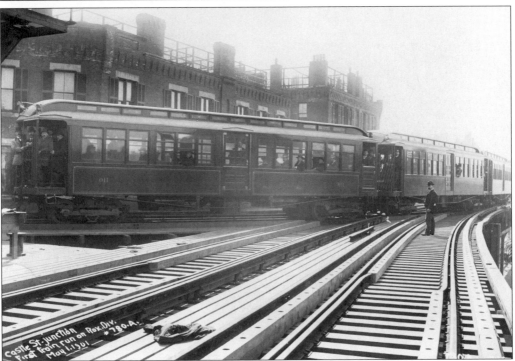

Here on the morning of May 3, 1901, the first trial train to operate over the Washington Street Elevated pauses at Castle Square Junction, where the Atlantic Avenue El diverged from the main line. Shortly after this picture was taken, the four-car train was broken into two two-car trains for instruction of train crews over the new line.

Five

THE WASHINGTON
STREET EL TO
FOREST HILLS

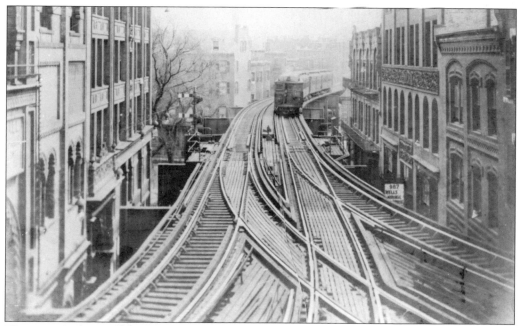

This view looks southward from Signal Tower D, which controlled the switches and signals at
Castle Square on the Washington Street Elevated. The train is heading for Dudley Street in
Roxbury. The track to the right connects to the Tremont Street Subway. The track curving to
the left in front of the Columbia Theater leads to Atlantic Avenue.

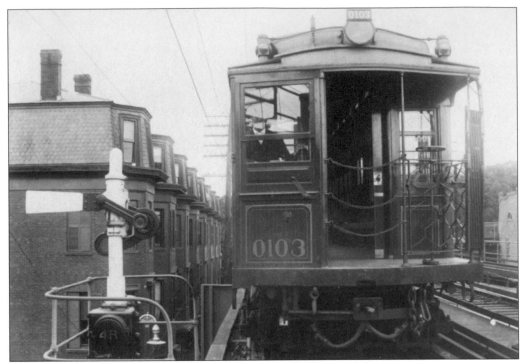

On June 26, 1902, an El train pauses at Washington and Guild Streets next to an automatic signal to advertise the Fail Safe Automatic Signal System installed on the El by the Union Switch & Signal Company. The system automatically applied the brakes to any train that failed to stop for a red signal. After its success in Boston, this type of signal system was quickly adopted by the London Underground system.

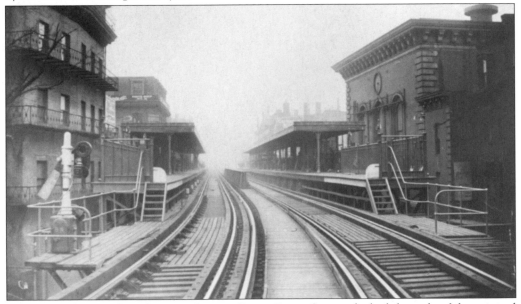

Designed to be strictly utilitarian, the new Dover Street Station lacked the style of the original station. The elegant Hub Theater Building, shown on the right in this December 1912 view, offset whatever charm the new station lacked.

This September 9, 1912 scene shows work under way on the new double-platform Dover Street Station, which replaced the original center-platform station. Taken looking north along the Washington Street El, the photograph includes the old Hub Theater on the right and the Boston Cadet Cigar Factory on the left. Cigar making was a major business in Boston at one time.

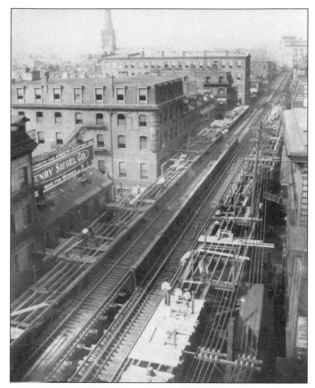

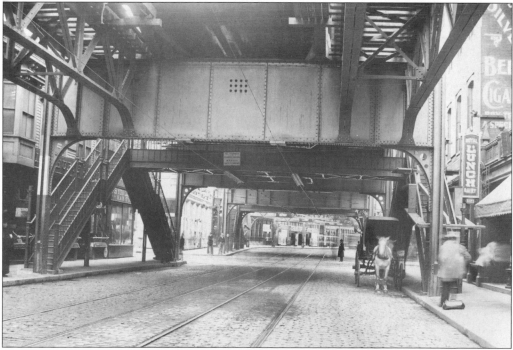

The original center-platform station sits above and dominates the intersection of Washington and Dover Streets on April 30, 1901. Most of the buildings in this view are gone, as is the El line and even Dover Street, which has been renamed East Berkeley Street.

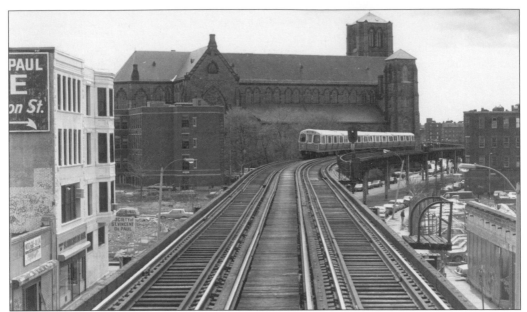

A Washington Street Elevated train of modern No. 12 El cars passes the Cathedral of the Holy Cross en route to downtown Boston and on to Malden. At the time this photograph was taken, the days of the elevated line were numbered. Although the El is now gone, the cars still exist and are used on the present-day Orange Line to Forest Hills.

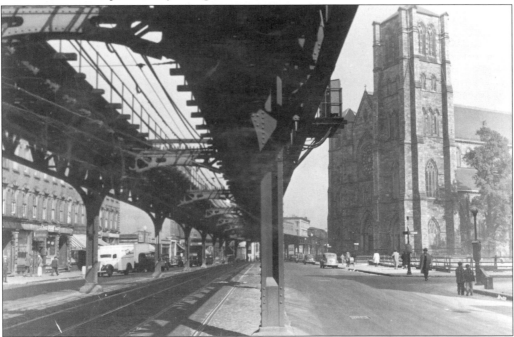

While the El was under construction, consideration was given to providing a station at the Cathedral of the Holy Cross, but the idea was eventually dropped. Over the years, arguments ensued in favor of a station to serve churchgoers versus those against a station that would deface the imposing façade of the cathedral. The Boston Elevated Company remained aloof from these arguments, and eventually the issue died out.

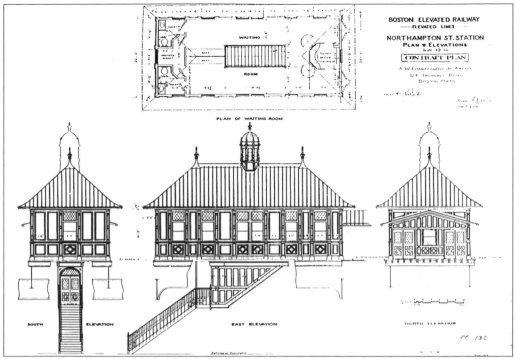

Except for the big terminals at Dudley Street and Sullivan Square, all of the intermediate stations on the original three elevated lines were built to the exact same design specifications as provided by noted architect Alexander Wadsworth Longfellow. Pictured is the plan for the Northampton Street Station, which survived unchanged until the end of the El service in 1979.

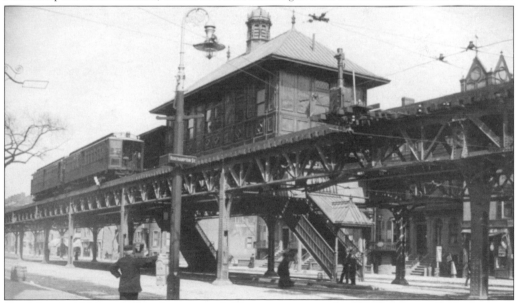

On May 3, 1901, a train of aurora red El cars pauses at the Northampton Station on an instruction trip. The exterior walls and roof of these El stations consisted entirely of pressed copper over steel framing. These stations stood up amazingly well, considering the air pollution and often daunting climatic conditions in Boston.

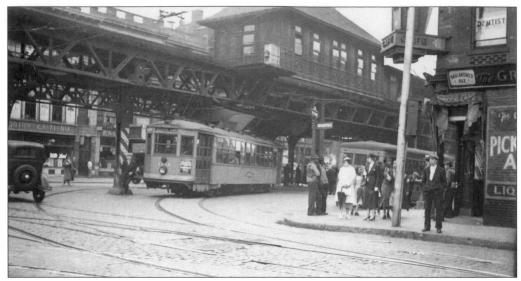

The junction of Northampton and Washington Streets was always a busy intersection during weekdays, with general traffic as well as buses and trolleys picking up passengers from the El station, as seen in this April 1938 view.

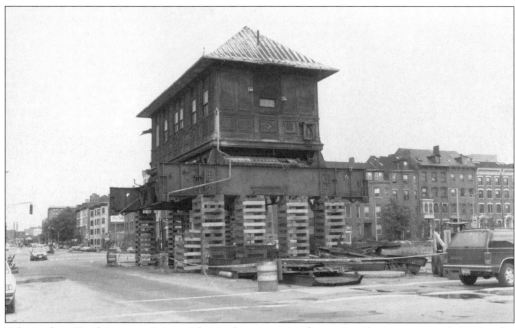

When the Washington Street Elevated was torn down in the summer of 1987, the Northampton Street Station was chosen to be preserved. In this view, the El line is gone and the station has been partially lowered to street level in preparation for moving. Today, the station is stored in a transit museum together with a number of the El cars that once served the line, all awaiting some future restoration.

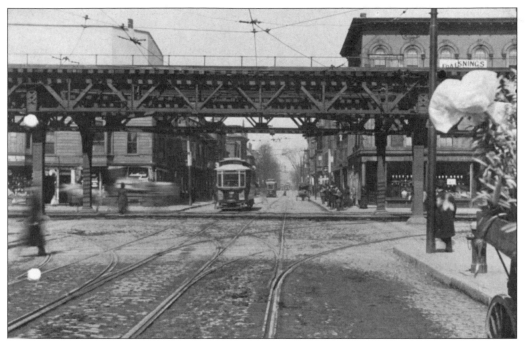

The trolley car at the intersection of Washington and Northampton Streets is bound for Upham's Corner in Dorchester and has virtually no traffic congestion to contend with. This view looks along Northampton Street toward Tremont Street in 1905.

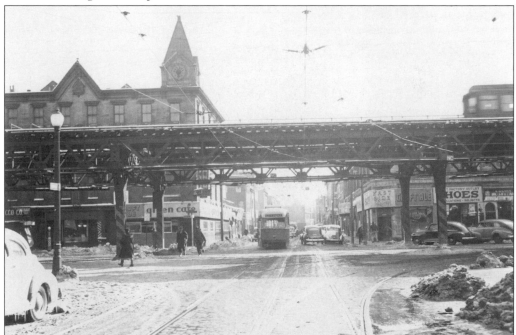

The same intersection appears in this view, looking from Northampton Street up Southampton Street toward the Boston City Hospital. On this wet and slushy day in 1947, the trolley car about to turn onto Washington Street is en route to Dudley Street Station from City Point in South Boston.

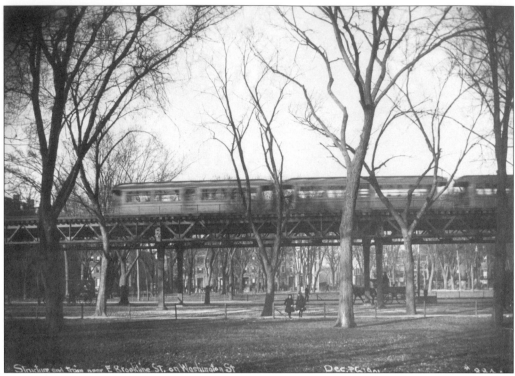

On the day after Christmas in December 1901, a train of wooden gate cars speeds along the Washington Street El amidst the bare tree limbs of Blackstone Park in Boston's South End. The two girls in the foreground may be discussing the lack of snow for the usual Christmas sledding.

On January 21, 1969, a Forest Hills-bound train of 1957 Pullman Standard cars approaches the Dudley Street Station. This section of Washington Street was once a vibrant shopping district with popular stores, such as Timothy Smith's, Dutton's, and the big Blair's Foodland, which is still located on the right.

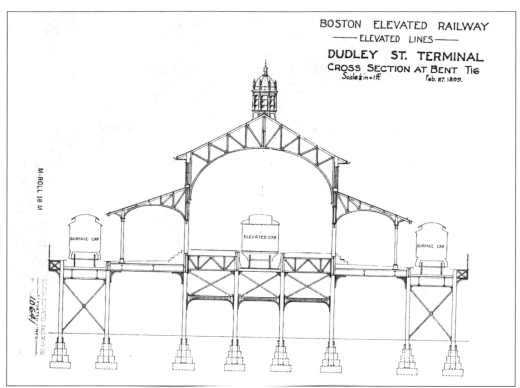

BOSTON ELEVATED RAILWAY
——— ELEVATED LINES ———
DUDLEY ST. TERMINAL
CROSS SECTION AT BENT 116
Scale ⅛ in = 1 ft. Feb. 27. 1899.

SURFACE CAR ELEVATED CAR SURFACE CAR

Unlike the big Sullivan Square Terminal, with its ten stub-end trolley tracks on the upper level, the Dudley Street Terminal had twin loop tracks for trolleys—one on each side of the El platforms, making for quicker movement of the surface cars. The lower level had four tracks for surface cars.

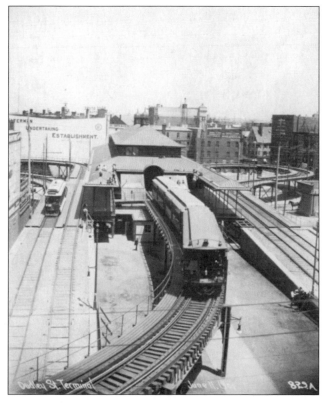

On June 11, 1901, the day after the El system opened for operation, a train enters the Dudley Street Station en route to downtown Boston as workmen finish applying the copper sheathing to the station roof. A Forest Hills-bound trolley descends the ramp to the street on the left.

109

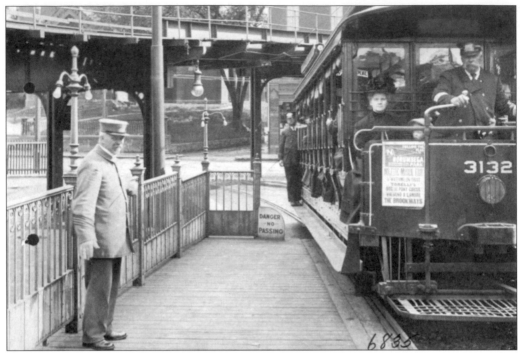

On an August 1901 morning, an open trolley ascends the ramp to the upper level of the Dudley Street Station, under the control of a stern-looking motorman. The gold service stripes on the motorman's sleeves indicate 30 years of service with the company. Neither the conductor on the running board nor the lady in the front seat feels moved to smile for the cameraman.

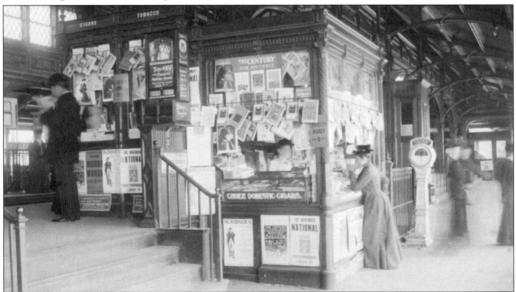

On the upper level of the Dudley Street Terminal are two back-to-back newsstands: the one on the left serving the El platform and the one on the right serving the surface car loading platform. The wide selection of candy and magazines seems to have the long-skirted lady in a quandary over what to buy. Note the pennyweight machine, a longtime feature of Boston El and subway stations.

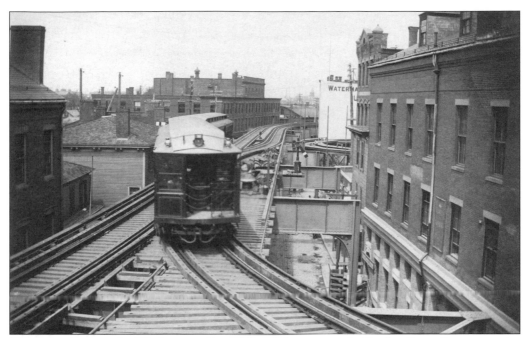

The first train over the Washington Street Elevated arrives at the Dudley Street Station on the morning of May 3, 1901. This view looks northward along Washington Street from the Dudley Street Signal Tower.

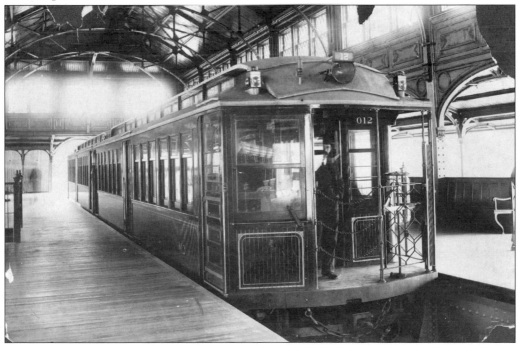

This view shows the same train, a few minutes later. Painted aurora red with silver gilt trim, Car 012 stands out in the Dudley Street Station setting, which is resplendent in polished mahogany, wrought iron, and leaded glass. The Boston Elevated Company displayed extremely good taste in designing the new El system.

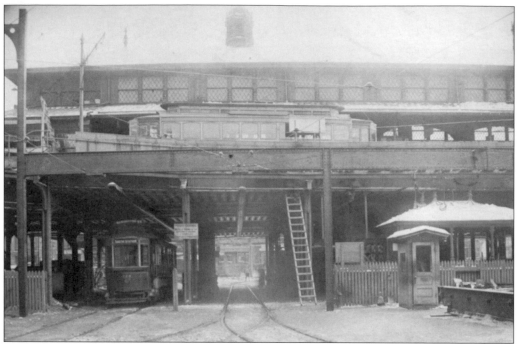

This photograph was taken from Washington Street, looking toward Warren Street, on a bleak January day in 1909. Looking through the surface level of the Dudley Street Station, it shows a trolley awaiting departure for the South Station via Washington Street. The car on the upper El level is bound for Roxbury Crossing and Jamaica Plain.

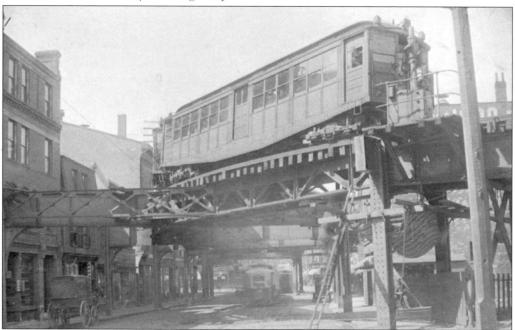

A train of new steel No. 3 El cars rounds the curve into the Dudley Street Station, en route to downtown Boston. In this view looking toward Washington Street on April 6, 1908, there is little activity on Dudley Street. The old Dudley Street Opera House is on the left.

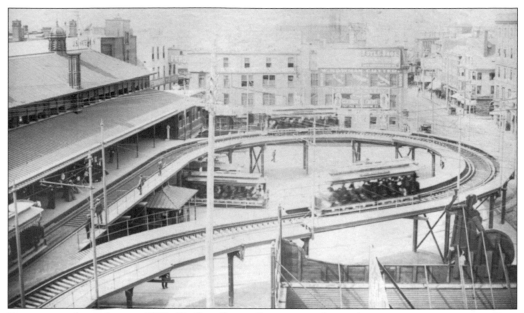

On a warm June day in 1902, Dudley Street Station is a busy place, as open summer trolleys arrive with crowds ready to take the El trains to downtown Boston. The upper-level east loop seen in this view was later enlarged and enclosed to handle the ever increasing ridership using this station. Warren Street is on the right.

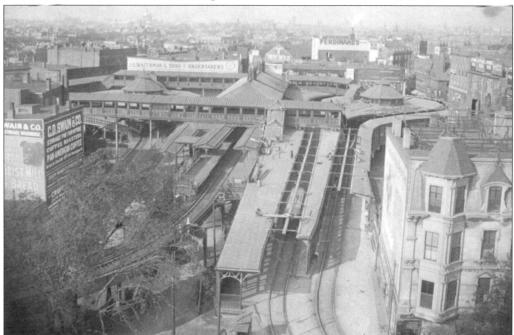

This September 20, 1910 photograph was taken looking down on the Dudley Street Station from the steeple of the Dudley Street Baptist Church. Both the east and west upper-level loops have been enclosed, and additional stairways and overhead passageways have been added to handle the growing passenger load. By June 1929, some 75,000 people per day used this station, which the *Boston Post* called a "Cattle Pen."

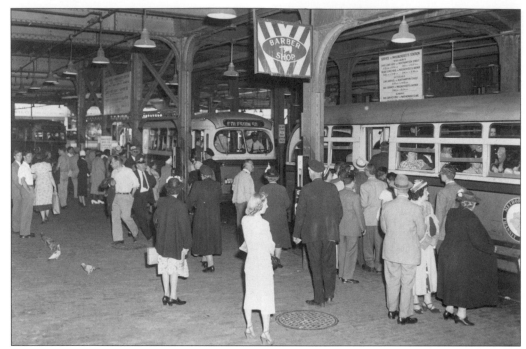

The red brick platform on the lower level of the Dudley Street Station is crowded as passengers board buses for Allston, Egleston Square, and Heath Street on June 12, 1950. Trolley cars for Massachusetts Avenue and City Point in South Boston also used this platform, keeping it busy from early morning to late evening.

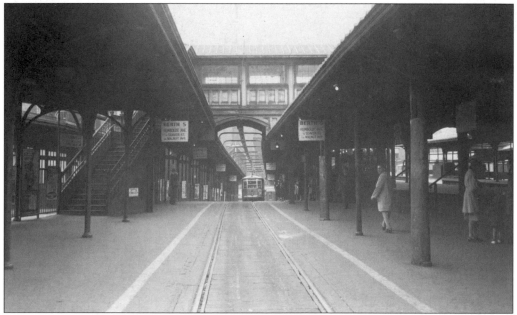

After being enlarged and modernized in 1910, the upper-level east loop at the Dudley Street Station remained pretty much unchanged for well over three decades, serving trolley car lines running to all points in Roxbury and Dorchester. In this October 8, 1946 view, a trolley car departs for Ashmont Station in Dorchester.

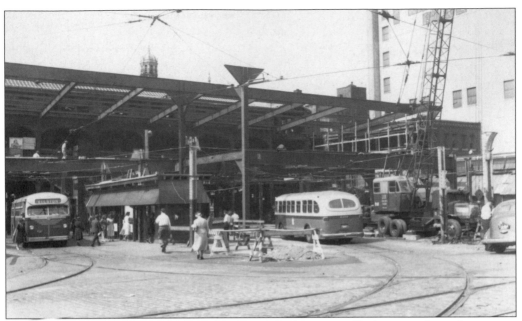

The decision by the Boston Elevated Company to substitute trolleybuses in place of streetcars on nine routes in Roxbury and Dorchester required the total rebuilding of the east loop to handle the new trolleybuses. In this September 9, 1948 view, steelwork for the new loop is being erected. The trolley cars were diverted to the adjoining west loop, and the project was carried out with no disruption to service—a feat not possible today.

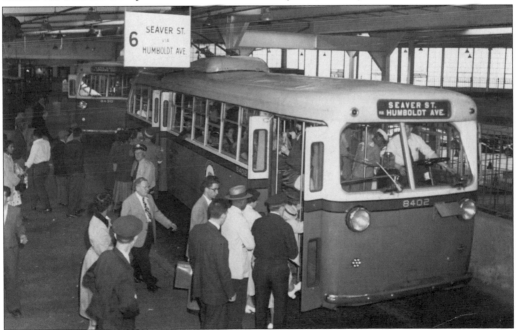

The new east loop project was completed in six months and opened for service on Christmas 1948. Most of the work was done by the Boston Transit Authority's own Engineering Division workforce. Passengers are shown boarding electric trolleybuses for Seaver Street and Upham's Corner on June 12, 1950.

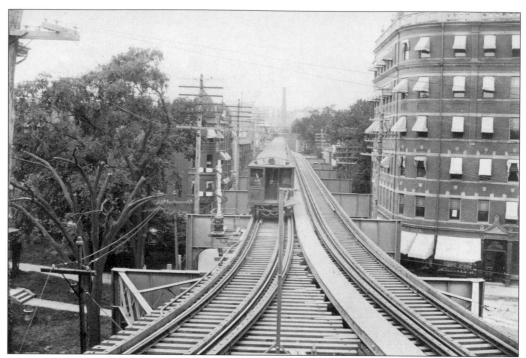

This photograph, looking south along Washington Street, was taken from the Dudley Street Signal Tower on July 13, 1901. A train approaches from the nearby Guild Street Car Shop. The apartment houses on both sides of the El line have just been completed, which seems to indicate that the desire to be near good transportation was more important than considerations of noise.

The rather small car shop at Guild and Washington Streets handled mostly routine inspection and light maintenance on the El cars. However, in this August 10, 1901 view, the workmen in the cars on the left are altering the car windows to open down from the top rather than up from the bottom. This was done to prevent passengers from spitting or tossing cigar butts from the trains onto pedestrians on the streets below.

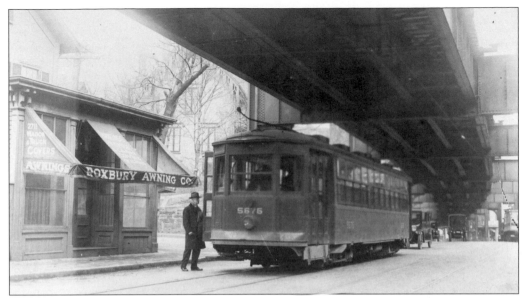

While the El trains provided speedy transportation above Washington Street, it was still necessary to provide local service to residents along the street below the El. This 1926 view shows a local trolley en route from Dudley Street to Egleston Square stopping for a passenger at Washington and Oakland Streets.

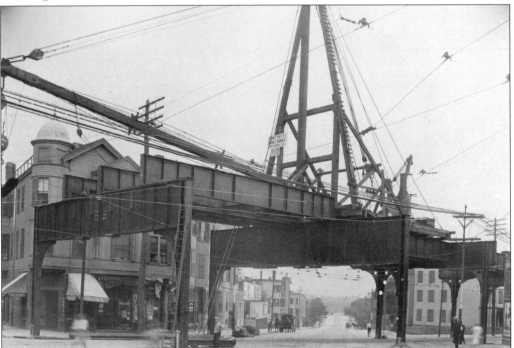

In August 1906, Egleston Square was still mostly residential with only a few neighborhood shops. However, the construction of the El station—shown in this view looking across Washington Street and down Columbus Avenue toward Jackson Square—generated commercial development. Development was further spurred by the opening of an adjoining surface car transfer station in 1917 on the site of an old carhouse.

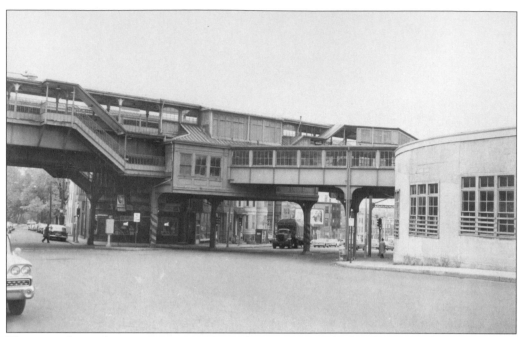

This view shows the same scene on November 1, 1962, with the El station above the square connected to the transfer station on the right by stairways and escalators. The transfer station was opened in 1917 in an effort to divert riders away from the badly overcrowded Dudley Street Station.

Trolley cars from Dorchester, Roxbury, Jamaica Plain, and the Park Street Subway Station loop through the surface-level transfer station at Egleston Square on September 26, 1938. In later years, buses served this station.

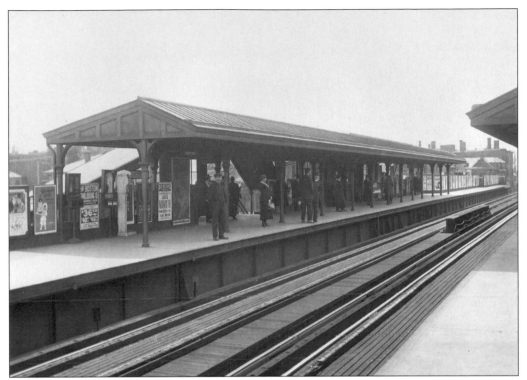

This view of the upper-level El platform at Egleston Square shows the somewhat plainer design of the stations on the Forest Hills Elevated Extension, as compared with the elaborate designs for the earlier El lines provided by Alexander Wadsworth Longfellow.

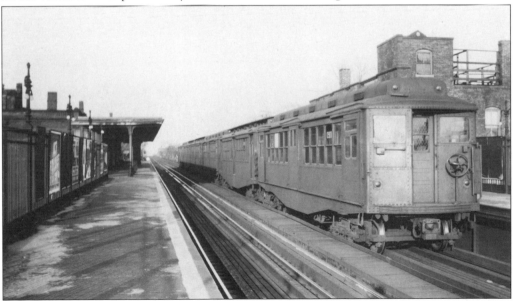

Similar in design to Egleston Square, the Green Street Station was added as an afterthought to placate local residents who felt that the distance between Egleston Square and Forest Hills was sufficient to justify a station in their area. In this January 1947 view, a six-car train departs Green Street for downtown Boston.

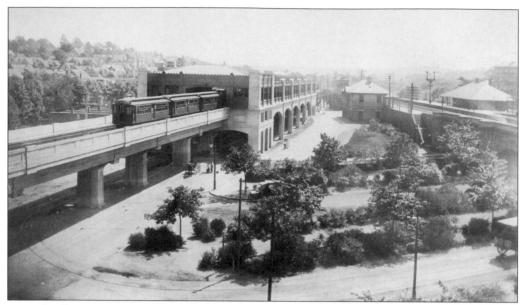

Special effort was taken with the design of the El line where it crossed Frederick Law Olmstead's "Emerald Necklace" at Forest Hills Square, shown in 1909 with the Forest Hills Railroad Station on the right. The El crossed the Jamaicaway on a handsome concrete viaduct, and the design of the Forest Hills Terminal was adapted from the Josephstrasse Station on the Vienna Rapid Transit System, which is still in use today.

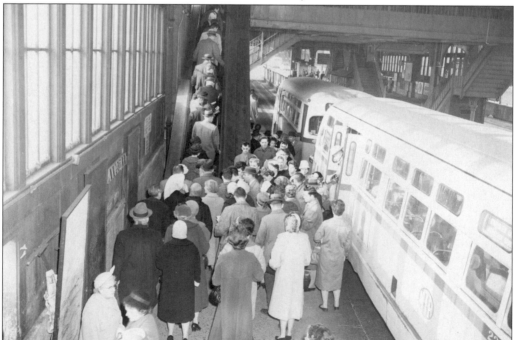

The morning rush hour at the Forest Hills Station is a busy scene on March 21, 1960. Passengers from arriving buses use the escalators to reach the train platform directly above. The compact design of the 1909 station stresses easy transfer for passengers: walking distance is kept to a minimum, and all walkways are under cover.

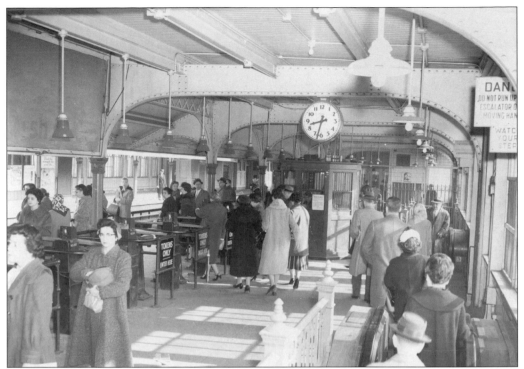

On March 21, 1960, after leaving their bus and walking less than 100 feet, passengers step off the escalator onto the inbound train platform. Boston Elevated Railway engineers always stressed efficiency and ease of transfer for passengers in their station designs.

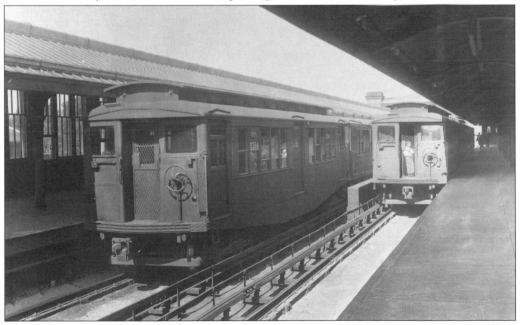

This scene shows the Forest Hills Station on a quiet and sunny September afternoon in 1950. One train arrives from Boston while an inbound train awaits the departure gong, which will send it on its way to downtown Boston and onto Charlestown and Everett.

In this interesting photograph taken on October 19, 1987, the old Forest Hills Terminal is on the right, awaiting demolition, and the new Forest Hills Terminal of the Orange Line is on the left. Although it was less than half the size of the new terminal, the old station easily handled three times as many daily riders.

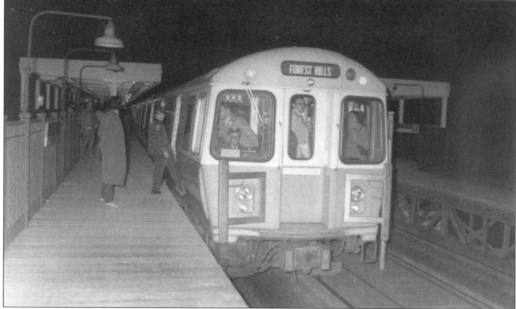

The Washington Street Elevated ceased operations early on the morning of May 1, 1987, bringing to a close 86 years of El operation in Boston. The last train to roll over the El from Forest Hills is seen at the Dover Street Station in Boston's South End at about 1:30 a.m. The new Orange Line opened on the morning of May 4, 1987.

Six

THE TRAINS WE RODE

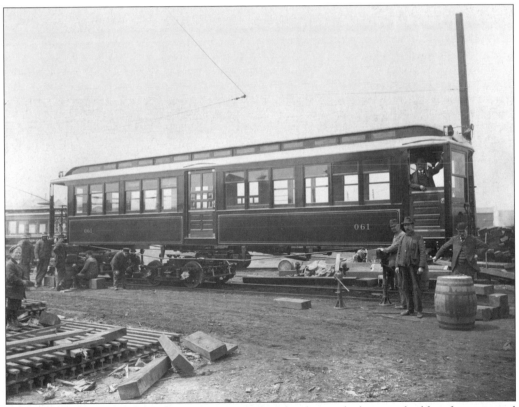

In August 1900, the Boston Elevated Railway placed orders with three car builders for an initial lot of 100 of its standard No. 1 El cars, as designed by the company's own in-house engineering staff. In this photograph taken on the morning of May 2, 1901, Car 061, built by the St. Louis Car Company, is lowered onto its motortrucks shortly after delivery at the Charlestown Yard.

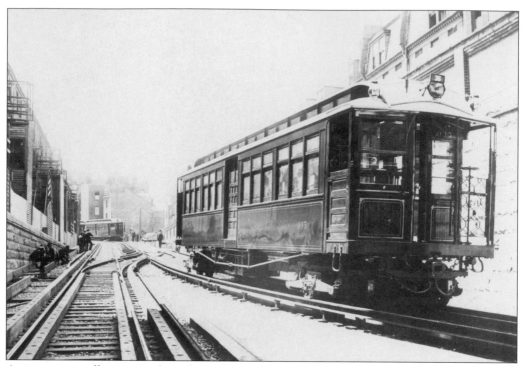

As soon as a sufficient number of new El cars were on hand and equipped for operation, the training of the train crew began. In this photograph taken in May 1901, Car 035 stands on the Pleasant Street ramp, which connected the south end of the Tremont Street Subway with the Washington Street Elevated. Instruction trips were being operated between this point and the Dudley Street Station to break in both the crews and the equipment.

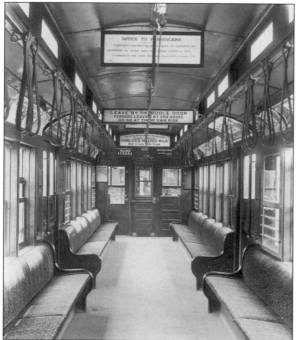

Typical of Boston El cars is No. 4 Steel Car 0223. The car's interior, shown on June 29, 1912, is painted a deep mahogany brown with a medium green ceiling. The lush seat cushions are a mottled red and black. The floor is cement. The hanging leather straps are provided for standees, of which there were many. The Pressed Steel Car Company built Car 0223 in 1911.

El Car 029 undergoes routine inspection and maintenance at the Sullivan Square Car Shops on February 4, 1904. Preventive maintenance and safety checks are extremely important on cars running high above city streets. At this time, the El cars were painted a drab olive green with brick red roofs and window sash. The Wason Car Company of Springfield, in business from 1845 to 1932, built Car 029.

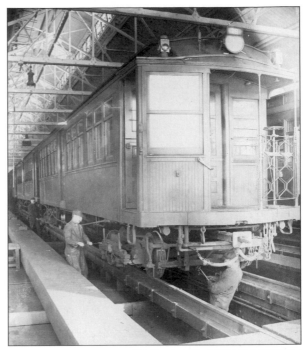

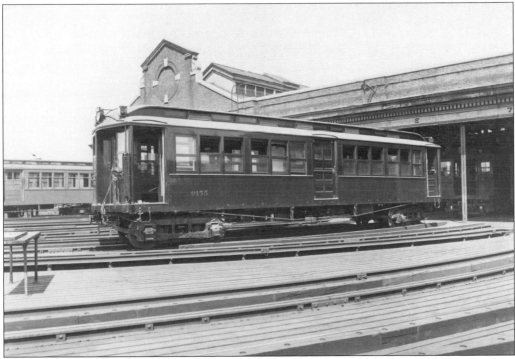

By 1903, officials of the Boston El had decided that their standard open-platform El cars with swinging gates and narrow end entrances were not able to handle the ever increasing ridership. John Lindall, superintendent of equipment, solved the problem by designing the No. 2-type El car with all-enclosed ends, air-operated doors, and an automatic starting signal. In this August 24, 1904 photograph, Car 0155 has just been delivered from the St. Louis Car Company.

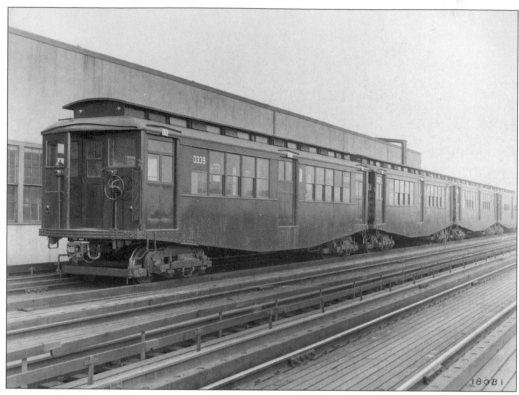

Shown at the Sullivan Square Shops on December 7, 1921, is a train of brand-new No. 8 El cars. Facing an ever increasing ridership, the Boston Elevated Railway Company ordered the No. 7- and No. 8-type cars from the Pressed Steel Car Company to handle the heavy traffic, as well as to replace some of the remaining wooden cars. All 107 cars in this group were in use by March 1922 and were retired in 1958.

Early in 1926, the Boston Elevated Company designed and purchased 100 steel cars to meet two pressing needs: first, to retire the last wooden cars in service; second, to handle the ever increasing ridership. One of the new No. 9-type El cars is shown on a flat car at the Laconia Car Company Plant in New Hampshire on March 25, 1927.

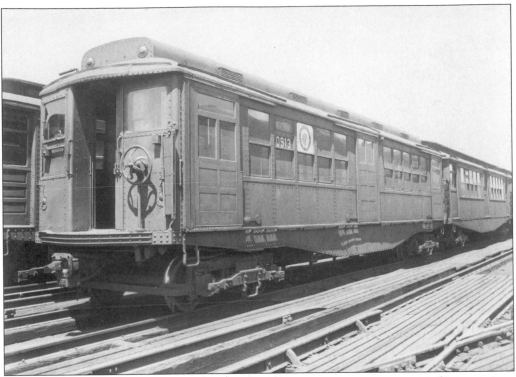

Still looking in quite good shape after 21 years of heavy service, No. 9-type El Car 0913 stands at the Sullivan Square Yard on May 19, 1948. Car 0913 continued in service for an additional 14 years before being retired.

In 1957, the riders on the El lines received a present of 100 new cars with comfortable upholstered seats and forced-air ventilation. A group of MTA and Pullman officials inspects one of the new cars at Pullman-Standards plant in Worcester, which closed upon completion of this car order. Second from the left is Edward Dana, who managed Boston's transit for more than 50 years.

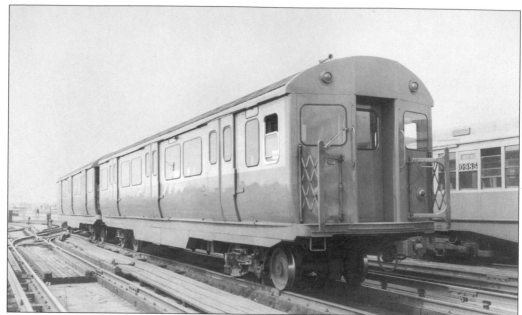

A train of the quiet, comfortable 1957 Pullman-built cars stands at the Sullivan Square Yard on May 12, 1958. These cars were prematurely cut up for scrap in December 1986 to forestall a legal move by Roxbury residents. Those residents sought to force the retention of the Washington Street Elevated as far as Dudley Street until the MBTA delivered on its longtime promise to install a light-rail line on Washington Street to replace the El. Today, the residents are still waiting for the light-rail line.

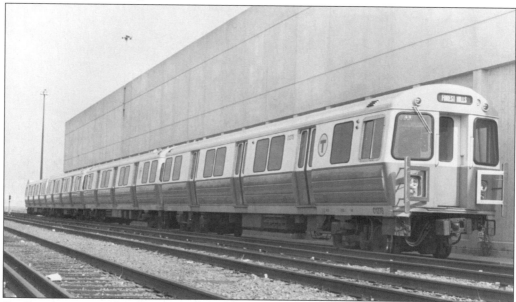

On June 9, 1976, the MBTA ordered 120 cars for the Orange Line and Washington Street Elevated from the Hawker-Siddeley Corporation of Thunder Bay, Ontario. These cars were the last cars to serve the Washington Street Elevated and now run on the Orange Line from Forest Hills to Oak Grove. These cars have proven quite satisfactory and are popular with the riders. This train is shown at the Wellington Car Shops in September 1981.